THEN & NOW

SCHENECTADY

Opposite: An elevated view of downtown Schenectady around 1890 reveals train and trolley tracks on State Street, Schenectady's main thoroughfare for over 346 years. The tower of the Edison Hotel looms on the right, while many commercial buildings line this historic street. This was the beginning of the period of Schenectady's growth as an important center of invention as Thomas Edison's General Electric Company became the major employer of the city. Invention after invention came out of General Electric and changed the way Americans would live forever.

THEN & NOW

SCHENECTADY

Don Rittner

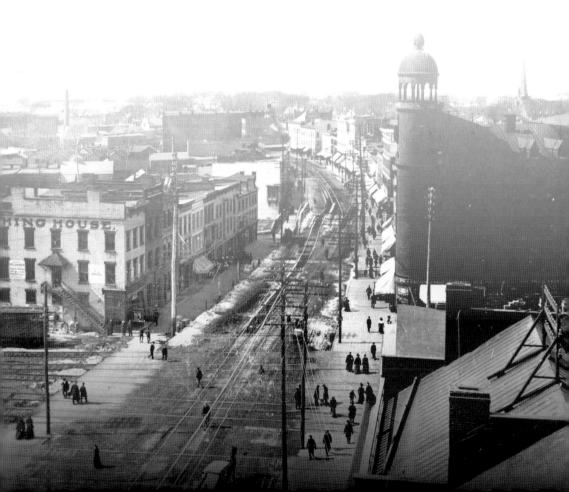

To Vincent Schaefer, William B. Efner, and Larry Hart,
three Schenectady men who knew the value of saving history

Library of Congress control number: 2007921758

Published by Arcadia Publishing
Charleston SC, Chicago IL, Portsmouth NH, San Francisco CA

Printed in the United States of America

For all general information contact Arcadia Publishing at:
Telephone 843-853-2070
Fax 843-853-0044
E-mail sales@arcadiapublishing.com
For customer service and orders:
Toll-Free 1-888-313-2665

Visit us on the Internet at www.arcadiapublishing.com

On the front cover: The early view shows downtown Schenectady's State Street around 1928. Trolley and railroad tracks crisscross the downtown as the tower of the Edison Hotel rises above many 19th-century buildings in the background. State Street was the major east–west corridor that connected people and goods between the Hudson and Mohawk Valleys. Originally a Native American trail, later called the King's Highway, it became the major trade, transportation, and military route west until about 1800. Today State Street is undergoing a renaissance with new building construction and restoration of many historic facades. (Vintage image courtesy of the Efner History Center, Schenectady City Hall; contemporary image courtesy of Don Rittner.)

On the back cover: Try growing these watermelons today! This contest at a shoe store at 328 State Street shows its winners who received a pair of horse blankets for fourth prize and a morris easy chair for third prize, and first and second prizes were for the women (prizes are unreadable). Ladies' shoes hanging in the window were priced at $2.50. On the right one could purchase a Ralston health shoe. (Courtesy of the Efner History Center, Schenectady City Hall.)

CONTENTS

ACKNOWLEDGMENTS

Special thanks go to Chris Hunter, Schenectady Museum archivist, and Cynthia Secord, archivist, Efner History Center, Schenectady City Hall, for their invaluable help and access to collections. Thanks also go to Pam O'Neil, my editor who has guided me through several Arcadia efforts. Moral support was given by Nick Barber, John Gearing, John Wolcott, little Jack Rittner, Greta Wagle, Anneke Bull, and Marieke Leeverink.

INTRODUCTION

Welcome to Schenectady, the city "beyond the Pine Plains." Schenectady is located on the banks of the Mohawk River, not far from where it empties into the Hudson River, some 160 miles from New York City. Strategically settled in 1661, Skenectada, as the Mohawks called it, referring to its location on the border of a large pine barrens, became the westernmost settlement of the Dutch-founded New Netherland region of North America. Its earlier frontier days as a trading post and later as an industrial center gives Schenectady a unique history that is not matched anywhere in the United States.

Founded by Arendt Van Curler and several families from nearby Albany in 1661, the stockaded village barely survived its early beginnings. The French and their Native American allies massacred most of the village inhabitants in 1690. The few survivors rebuilt the village, with the help and support of their Mohawk allies, and Schenectady went on to provide leadership through the American Revolution, helped win the Civil War with technical contributions to the USS *Monitor*, and by the late 19th century became the center of electrical innovation and discoveries when Thomas Edison located his company on the fertile Mohawk River flats.

It is no surprise that the first steam-powered passenger train, the Mohawk and Hudson Railroad, was chartered here in 1826 and that within a few years, Schenectady was the hub of the American railroad industry. With the consolidation of several locomotive companies into the American Locomotive Company in 1901, Schenectady became known as the city that "lights and hauls the world."

Schenectady is a city of invention and many notable scientists were drawn here for the freedom to experiment. Charles Steinmetz, Ernst Alexanderson, William Coolidge, Irving Langmuir, and native son Vincent Schaefer, to name only a few, made major contributions to science over the last century. It is the city where television and fax were first broadcast. The world's first television station, WRGB, still broadcasts daily. WGY, one of the earliest radio stations in America, still sends its 50,000-watt signal reaching as far as South America. It is also the place of invention for many modern necessities from lightbulbs, refrigerators, X-rays, jet engines, and turbines, to name a few. Five Nobel Prize winners worked, lived, or were educated in the city: Irving Langmuir, Ivar Giaever, Baruch Blumberg, Martin Perl, and Jimmy Carter.

Schenectady is not all science. It has also been part of American pop culture and has contributed to art and sports. The city is featured in Dr. Seuss's *I Can Read with My Eyes Shut* and in two poems, one by Eve Merriam called "Schenectady" and Medora Addison's "Names." Schenectady is the hometown of the character Grace Adler on the NBC television sitcom *Will & Grace*. Barry Longyear's science fiction collection titled *It Came from Schenectady* is from Harlan Ellison's reply when people asked him where he came up with his ideas. The fictional comic book character Doctor Octopus from *Spider-Man* is from Schenectady, as well as the title character of Henry James's 1878 novella *Daisy Miller*. Kurt Vonnegut lived in Schenectady while working for General Electric in the early 1950s (his brother Bernard worked with Vincent Schaefer in the State University of New York (SUNY) Atmospheric Sciences Research Center and made major discoveries in cloud

science). Director John Sayles was born and raised in Schenectady; the Schenectady High School of Fine Arts wing is named after him. Shirley Muldowney, the first lady of drag racing was born and raised here, as well as basketball coach Pat Riley. Sir Charles Mackerras, the famous British conductor, was born in Schenectady while his father was taking an electrical engineering course at Union College. Actors Mickey Rourke and Ann B. Davis (Alice on *The Brady Bunch*) were born here.

The city has been featured in film and television productions such as the German-made *Angebot aus Schenectady* (1971). In 1972, director Sydney Pollack filmed flashback sequences of the movie *The Way We Were*, starring Robert Redford and Barbra Streisand. In 2002, scenes from the *Time Machine* were filmed here. Ranald MacDougall from Schenectady was the screenwriter for the 1945 war movie *Objective, Burma!*, starring Errol Flynn. He was also president of the Screen Actors Guild from 1971 to 1973. The first television drama ever shown in the world was *The Queen's Messenger*, sent over WGY in 1928. Mantan Moreland played the role of Schenectady in the 1941 *Mr. Washington Goes to Town*. Kevin Burns, who has produced, directed, or written more than 100 films, was raised in Schenectady. Television legend Dave Garroway was born here. Some 60 known actors have been born or raised here.

There are few cities in America that are 346 years old, and Schenectady has seen its share of successes and hardships. Its history, however, is genuine and lasting. Much of the city's history has been preserved. A visit to the Stockade, New York State's first historic district, will reveal Dutch Colonial architecture of the 17th century. Many of the industrial buildings, such as General Electric, American Locomotive, and Schenectady International are still in use or being renovated for new uses. The General Electric Realty Plot is a showcase of architecture and was home to many of the General Electric's most notable figures. A new revitalized downtown with arts, theater, and retail is bucking the trend of other northeastern cities that have suffered from the suburban exodus of the last 30 years.

This book is a walking field guide to Schenectady's main arteries, State Street and the Erie Canal, now Erie Boulevard. State Street, which runs east and west, was originally part of a great Native American trail that was widened into a wagon road around 1663. Known as the King's Highway, it connected the two frontier settlements of Schenectady on the Mohawk River and Albany on the Hudson River. This road was the lifeblood between the two as a link for people, goods, and security. It was also the main area in which settlement expanded out of the stockade to form the city proper.

The Erie Canal cut through the city in 1825 and runs north and south, almost creating a commercial and residential island between it and the Mohawk River to the west. Many of the industrial establishments of the city located along the canal prospered. However, by 1915, with the establishment of the Barge Canal system and more use of the river system, the canal was filled in to become the largest well-lit boulevard in the country at the time.

This book is divided into three walking sections: State Street and the Erie Canal, north and south. You should start at the beginning of State Street at Washington Avenue and walk up to Erie Boulevard. From there you can continue to walk up State Street to Crescent Park and back down to take the canal route, or you can go north or south on the canal route once you reach the boulevard. While you walk with this book in hand and view the many changes that have taken place over the years, try to realize how much of being a modern American has originated from these historic streets. There is no other city in the world named Schenectady. Likewise no other city has made such a lifetime of contributions that continue to benefit humanity.

Don Rittner
Schenectady, January 2007

CHAPTER 1

STATE STREET

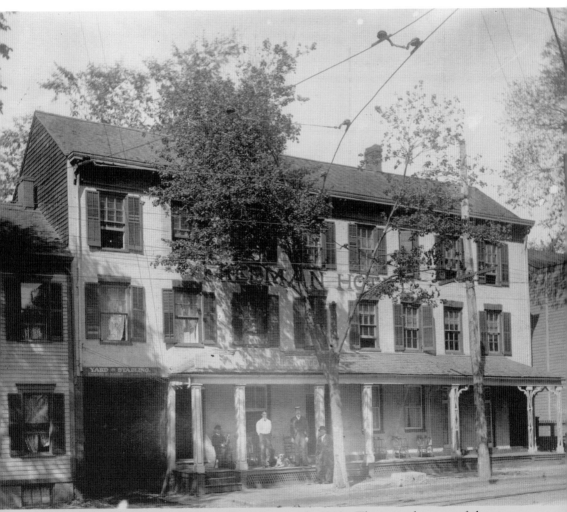

The Freeman House was located at the foot of State Street and Washington Avenue and was one of the city's oldest hotels. It was destroyed, along with others, when the Van Curler Hotel and the new Western Gateway Bridge were built in the early 1920s. This was also part of the site for the King's Fort, a stockaded compound built after the Schenectady massacre in 1690 to house the survivors and their Mohawk allies.

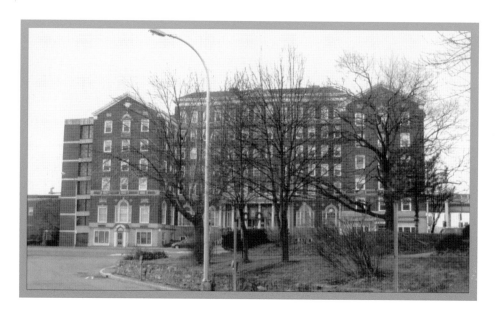

The Van Curler Hotel opened in April 1925 and caused quite the excitement in the city as the largest and most modern hotel with a huge ballroom and solarium. For many years, it was the place to be seen. With the influx of motels during the 1950s and 1960s, the Van Curler Hotel became unable to compete and closed its doors on February 2, 1968. It was saved from the wrecking ball when the county purchased it four months later for the community college, opening in September 1969. It continues to serve the county population with excellent education and is known for having a top-rate culinary department.

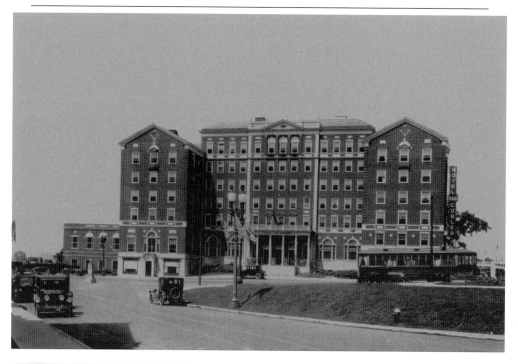

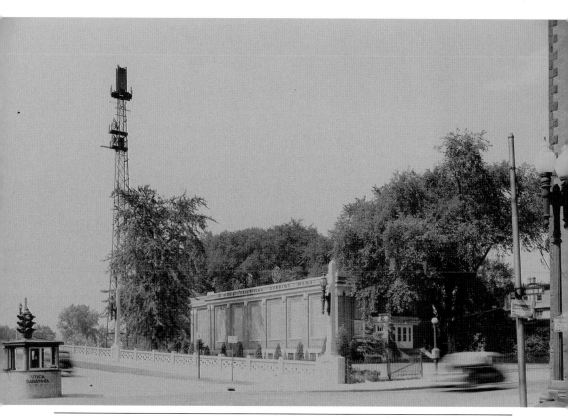

On May 11, 1928, the first television station in the world was launched in Schenectady. WRGB-6 occupied this building on December 19, 1941, and it was heralded as the most modern television production facility in the country and the first building created solely for the purpose of television.

WRGB continues to broadcast in nearby Niskayuna, making it the oldest television station in the world. This building is now the Center for Science and Technology and belongs to the Schenectady County Community College.

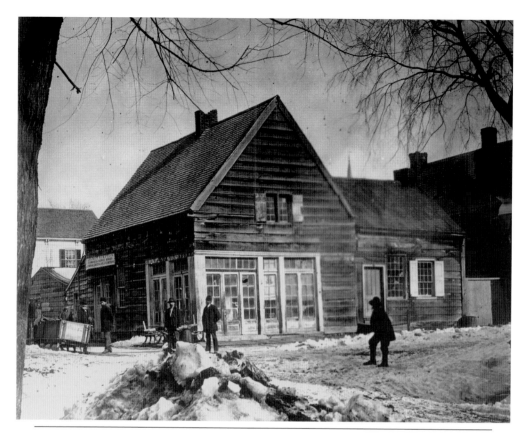

On the northeast corner of State Street and Washington Avenue, around the 1870s, was the business of the James Simpson Carriage, Sleigh Maker, Horse Shoeing and Blacksmithing shop. Originally built around 1730, the shop was torn down in December 1895 for the apartment house that exists there today. The *Mohawk Mercury*, Schenectady's first newspaper, was first published here on December 15, 1794. Over the years, the building also served as the post office and as a private school.

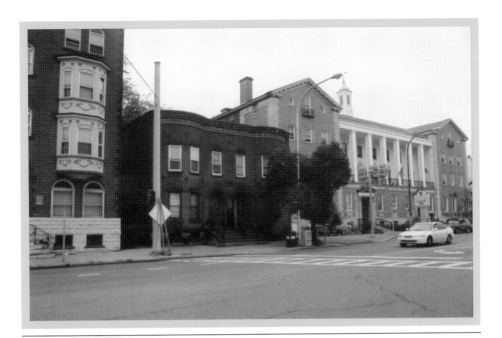

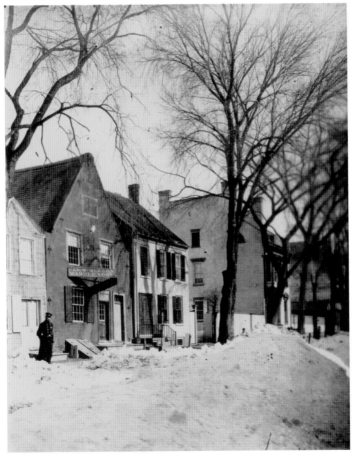

The Brandt family was one of the founding families of Schenectady. The Arendt Brandt House stood at 7 State Street. It is pictured in the late 1890s, with a policeman standing nearby (to the left). It was a saloon at one time and, as seen in this image, operated as the J. W. McMullen Marble Works. Electrical genius Charles Steinmetz photographed the dismantling of the building in 1895, showing how the Dutch erected their early houses. The YMCA now occupies this site.

The first home of George Westinghouse and family was located at 16–18 State Street. George Westinghouse Jr. went to Union College here before he moved to Pennsylvania to start the Westinghouse Electric Corporation, one of Thomas Edison's chief rivals. While here, he worked for his father in his agricultural works along the Erie Canal just south of here. At 22 years of age, he developed the air brake, a device that stopped trains using compressed air. In his career, he had 361 patents.

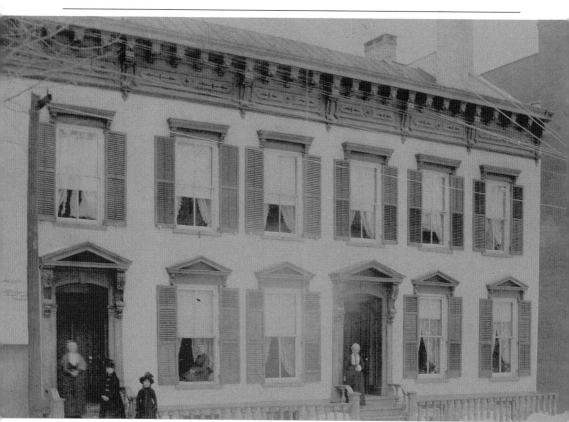

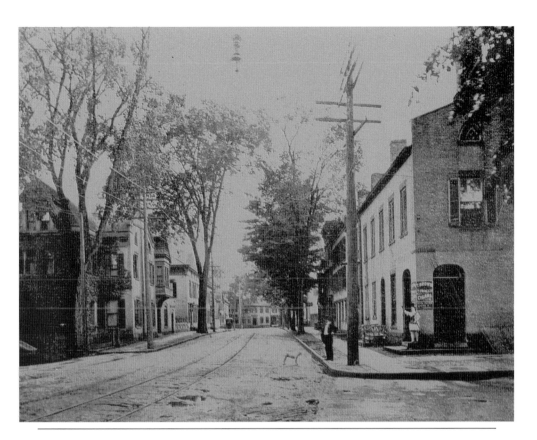

Shown is lower State Street from Church Street to Washington Avenue. This was called Martyrs Street, since many of those killed in the 1690 massacre were buried near the old Dutch church that once stood here. In the 1892 view, the house on the left is that of George Westinghouse Sr. His son George grew up here and went on to form the Westinghouse Electric Corporation. The Freeman House can be seen at the end of the street. Today the entrance to the Scotia Bridge is on that site.

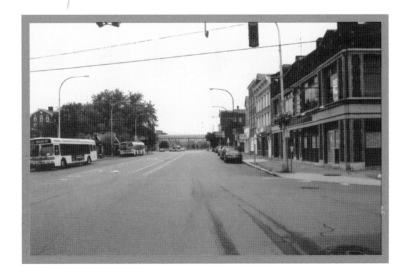

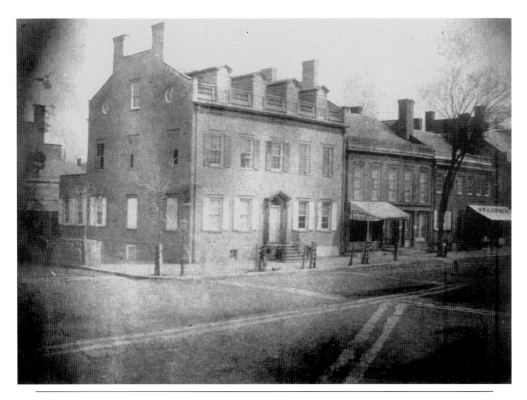

The Daniel Campbell Mansion, built in 1762, is located at the northeast corner of State Street and Church Street. Daniel Campbell, an Irish businessman, was a strict loyalist during the American Revolution. He finally gave an oath of allegiance to the American cause or would have been forced to leave Schenectady. Sir William Johnson often visited him here.

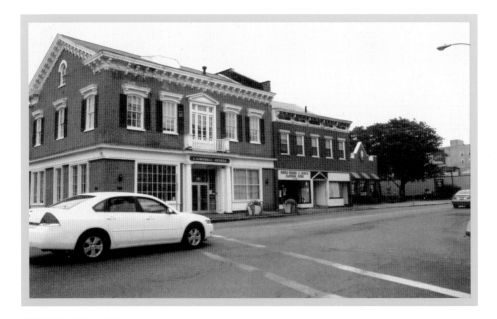

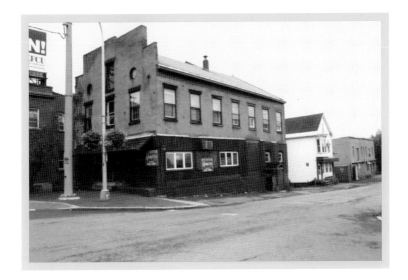

This building, known as the blockhouse and located at 101–102 South Church Street, was the S. and Chine Laundry in 1914. In the 1930s picture, it is serving as a restaurant. Actually there are two buildings here that were originally residences. To the left of this building is Mill Lane, one of the oldest original lanes in the stockade, and it is here where Sweer Teunise Van Velsen had built the first gristmill in the Mohawk Valley in 1666. He was killed in the massacre in 1690, along with his wife and four slaves.

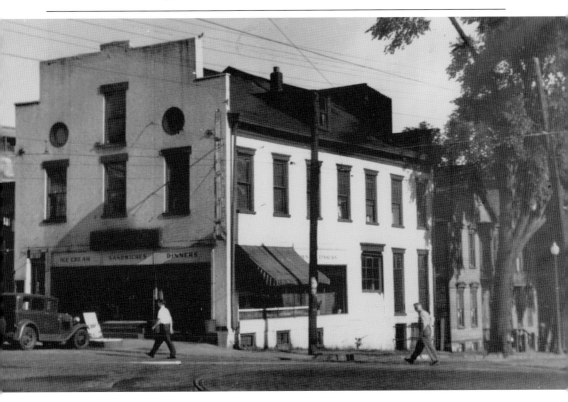

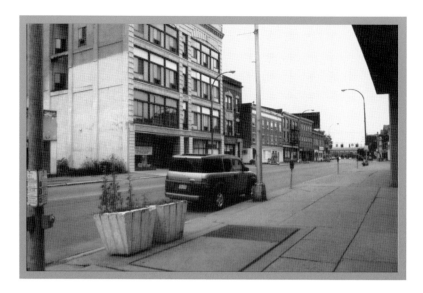

Shown is the south side of lower State Street from Ferry Street looking toward the Mohawk River. The c. 1870s photograph shows that lower State Street was mostly residential well into the 19th and 20th centuries. Several of the remaining buildings still serve as apartments on the upper floors. Much of the original streetscape has been removed in this section of Schenectady.

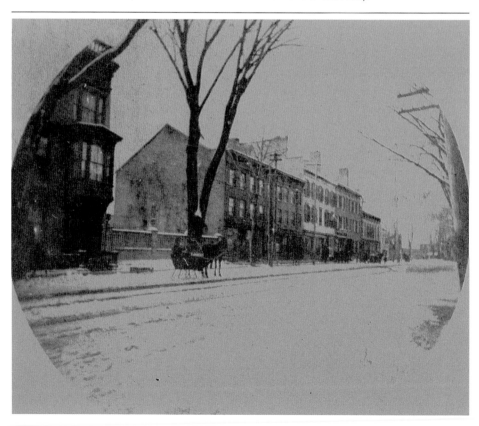

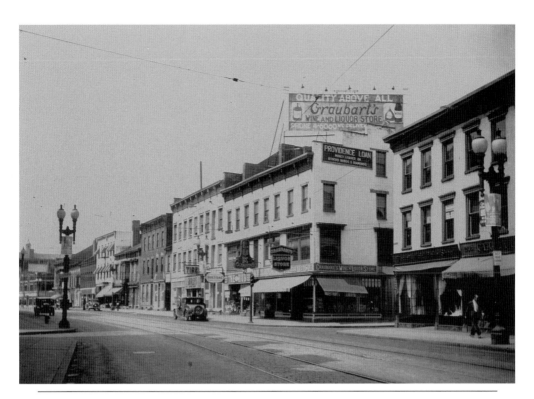

This is the north side of lower State Street from Ferry Street to Washington Avenue. This area of lower State Street was the first place that residents settled after moving out of the Stockade section of the city. Many of the residential buildings were converted to commercial buildings during the late 19th and early 20th centuries. The Furman Block building (right) is one of the last remaining 19th-century buildings on this block. George Westinghouse Jr. invented the air brake for trains on the third floor in this building. Col. Robert Furman helped build Crescent Park by donating land and was one of the founders of the YMCA in 1858.

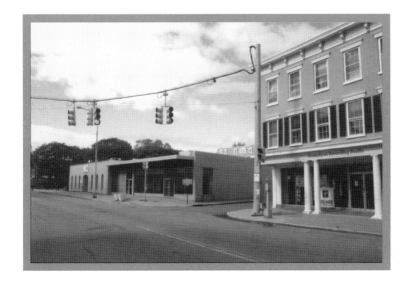

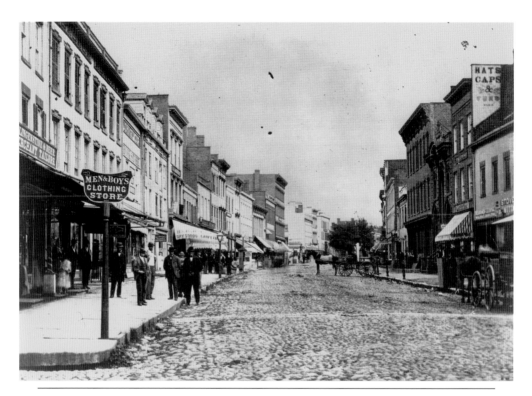

Clothing, books, stoves, and dry goods could be purchased on this block from Ferry Street to the Erie Canal in the 1870s. H. S. Barney (left) was one of the most successful stores, lasting well into the 20th century. This part of lower State Street still has much of its 19th-century charm, although the cobblestone street was replaced over a century ago.

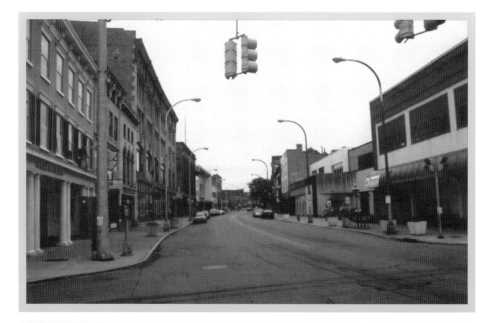

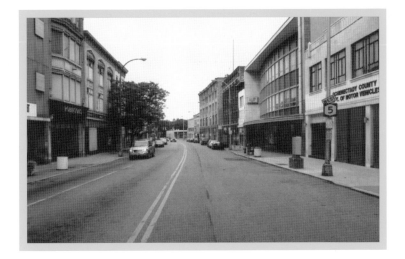

Shown is lower State Street, looking from the canal west toward Ferry Street. On the left in the early-1900s view is the original Carl Company. Trolleys, wagons, and early automobiles were soon to make this a congested thruway. In the 1960s and 1970s, new buildings replaced several of the 19th-century stores. Today a renewed interest in revitalizing lower State Street is encouraging a move to bring back the 19th-century streetscape.

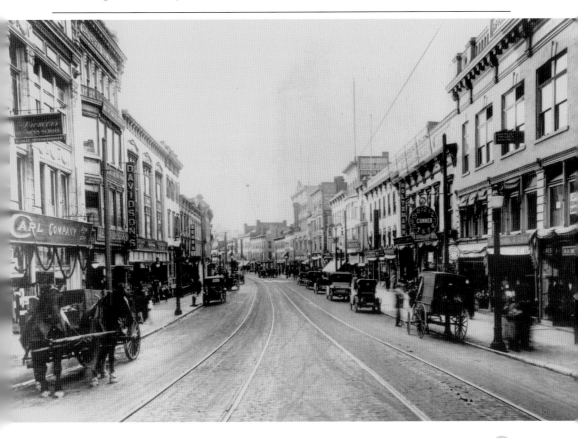

STATE STREET

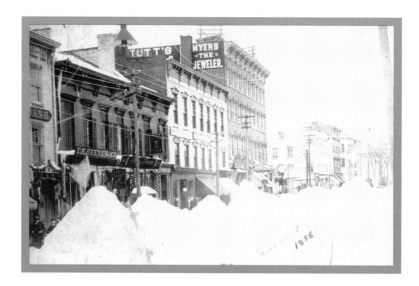

In the blizzard of 1888, looking east toward the canal, snowbanks are high on State Street. The National Weather Service estimated that 40 inches covered New York State and New Jersey. Winds blew up to 48 miles an hour, creating snowdrifts 40 to 50 feet high. The Myers Block at 151–157 State Street was replaced by the Wedgeway and Kresge Buildings.

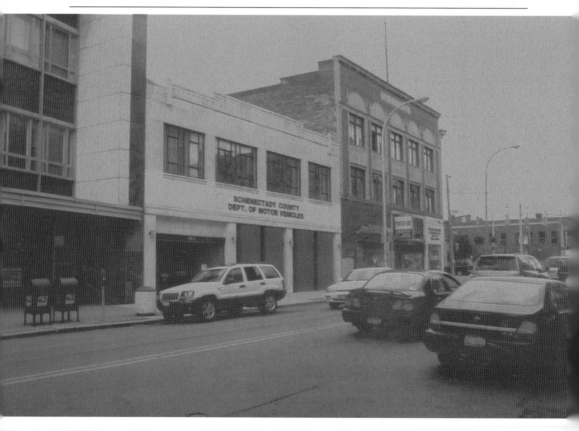

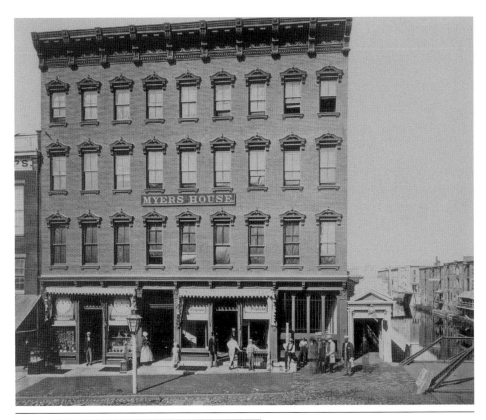

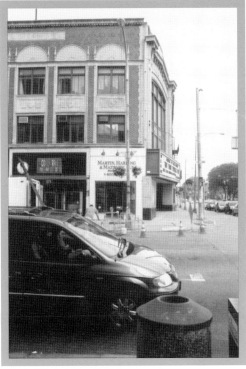

The Myers House, formerly the Sharratt House, was built in 1868 on the north side of State Street. George Lackhurst was the proprietor. It was one of 17 hotels in the city in 1886 and stood next to the canal (seen on the right). The World Refreshment Saloon was the little addition overlooking the canal to the right of Myers. The Kresge and Wedgeway Buildings replaced the Myers Block. The Wedgeway advertised as the largest office building in Schenectady during the 1930s and still is in operation.

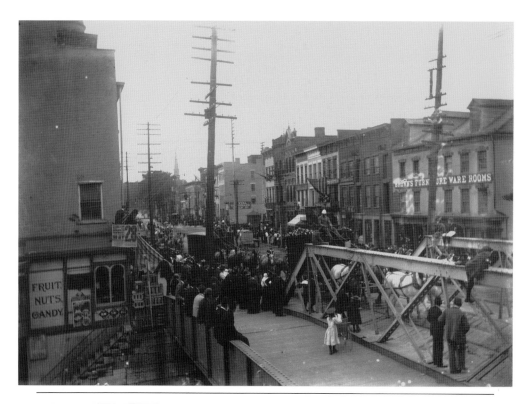

The Ringling Brothers circus is seen coming to the city on May 28, around 1898. This photograph by Charles Steinmetz shows the circus parade moving up State Street and crossing the canal at the bridge. Notice the little girl on the bridge. Brown's furniture store is where the Masonic temple now stands on the southeast corner. It was built in 1825 shortly after the canal was built and was known as the Schuyler Inn, and then later as the Putnam, Fuller and Germond Hotel, and the City Hotel, and finally Arthur Brown purchased it in 1872.

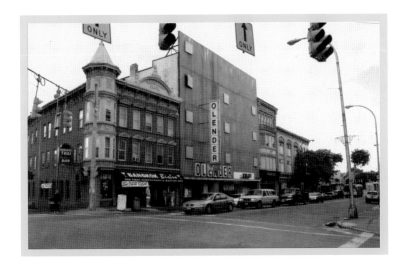

The Nicholas Block, on the southwest corner of State Street and Erie Boulevard, was remodeled in 1901. It became a famous restaurant and landmark for years, operated by Louis Nicholas and family until 1975. Loppa, the family parrot, was a familiar sight at the restaurant from 1901 to 1936. The bird was then stuffed and spent many years in the Efner History Center in city hall. The Fern and Economy furniture stores are to the right. This is one of the few intact 19th-century blocks left in the city.

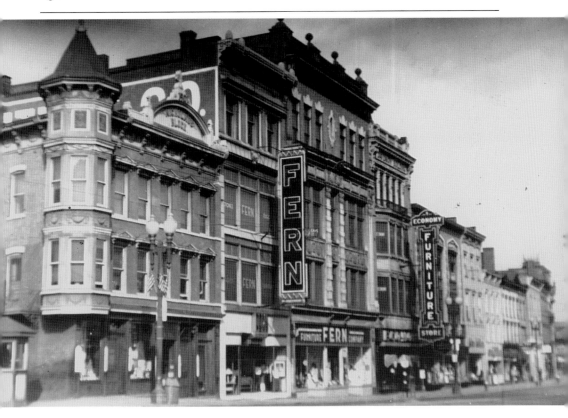

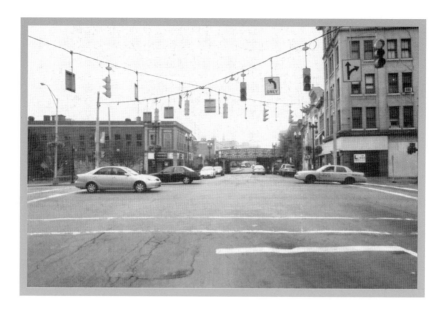

From 1880 to around 1930 was a prosperous time for the city, as General Electric, American Locomotive, and others were in full operation and employed many Schenectadians. The early view shows the Erie Canal Bridge at State Street, with the Ellis Building (left), now demolished, and the Masonic temple (right), which can also be seen in the present-day view.

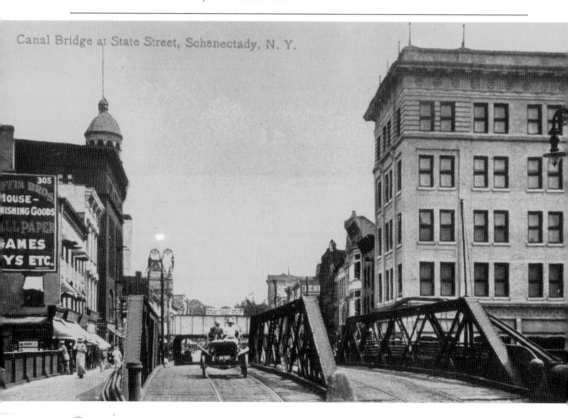

Canal Bridge at State Street, Schenectady, N. Y.

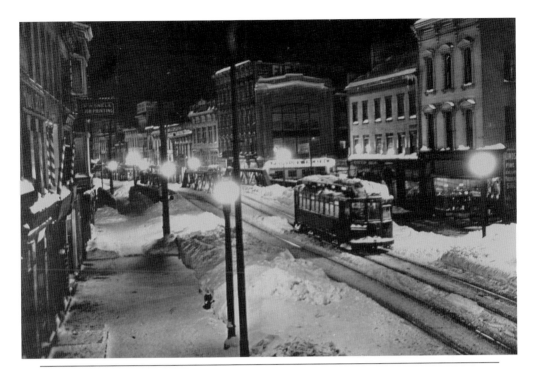

In this c. 1910 photograph, trolleys and the canal were major movers of people and goods. The first Proctor's Theater is in operation at the Wedgeway Building (originally the Wedgeway Theater). Wall Street is to the right of Lindsay's Shoe Store. The Ellis Building, another landmark, is on the northeast corner of State Street and the canal.

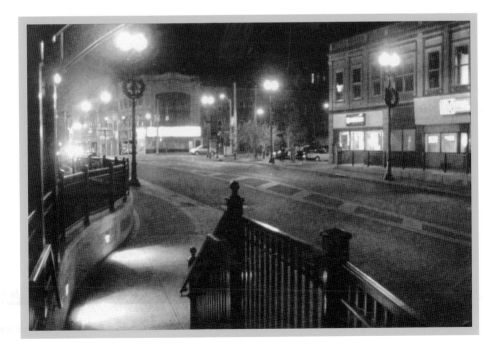

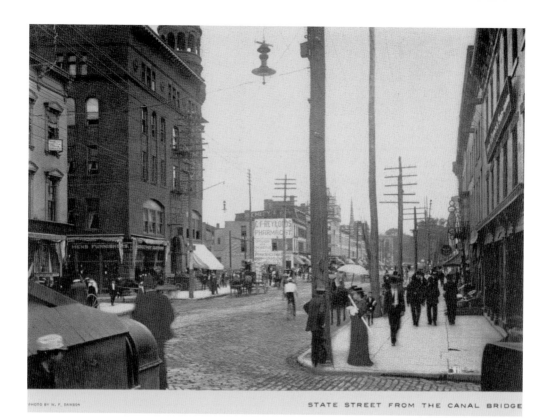

STATE STREET FROM THE CANAL BRIDGE

An early-1900s view of State Street looks east from the Erie Canal. The Edison Hotel is the large building on the left. It replaced the earlier Givens Hotel (demolished in 1889) in 1890. The Vendome, another landmark hotel, is farther up on the corner of Broadway.

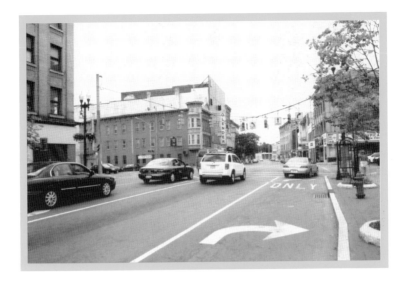

Workers are replacing native cobblestone along State Street at the Erie Canal Bridge with Belgian block pavement in 1895. Trolley tracks can be seen running both ways on State Street. Notice the early electric light on the pole. Brown's Furniture Ware Rooms store (left) was rebuilt in 1912 but went out of business in 1917. The building was sold to the Masonic Order, which converted it into its present-day temple. Helen C. Brown founded the Brown School, a private school that continues today.

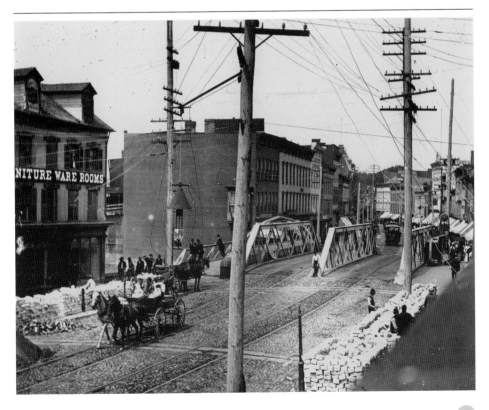

This view is of the Edison Hotel and a trolley heading east on State Street, around 1890. The trolley is crossing the train tracks, which later were elevated, a project completed in 1907. The first two floors of the Edison are incorporated into the present-day Cushing Building.

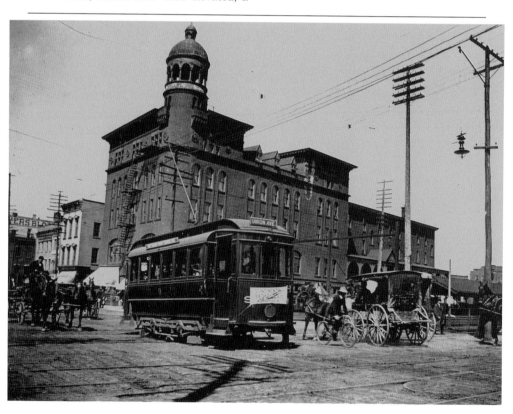

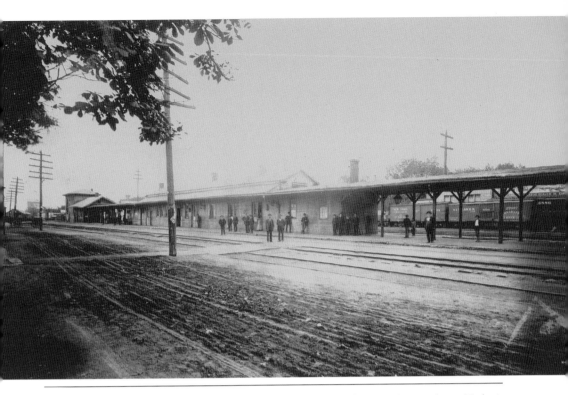

The first steam-powered passenger train in New York State was the Mohawk and Hudson Railroad, and its first station was located on top of Crane Street Hill. Pictured is a later Schenectady station, built in 1842. That station was replaced by a Moorish-style one 40 years later. Today's railroad station has a historic marker that reads, "At this site Thomas Edison arrived at Schenectady Aug 20, 1886 to found his machine works which in 1892 became the General Electric Company."

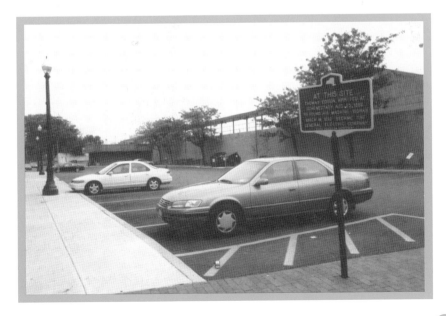

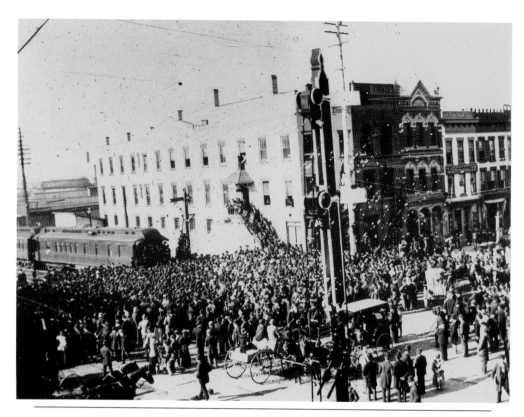

A crowd gathers at the train station to listen to newly elected president William McKinley in March 1897. Shortly afterward, due to pedestrians being killed crossing the tracks, the city required the railroad to elevate the tracks.

Schenectady's 1882 railroad station was a Moorish-style station with a beautiful cast-iron fountain. The station lasted for 23 years and was replaced in 1908 by a new union station. This location has been the center of rail traffic for over a century.

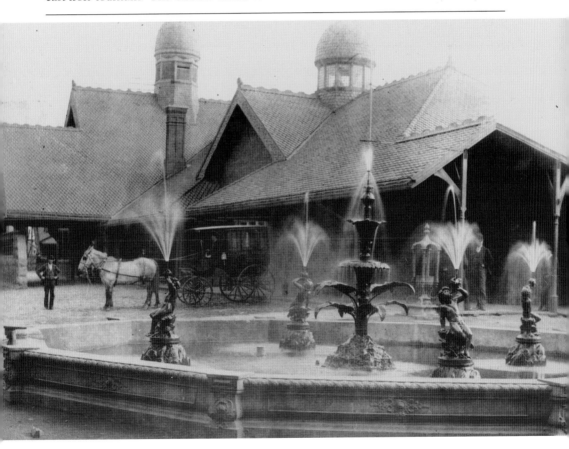

Union station was one of the centerpieces of the city during Schenectady's heyday. Built in 1908, it was closed in 1968 by the Pennsylvania and New York Central Transportation Company, more commonly known as Penn Central, and was razed in 1971. The current station was built in 1979, and it too is scheduled to be replaced in the near future.

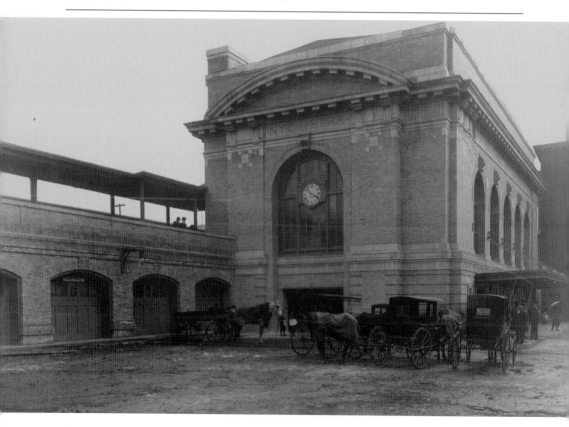

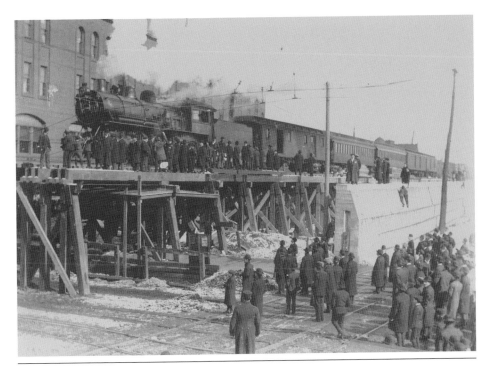

After several pedestrian deaths by trains running through the city, the tracks were finally elevated between 1901 and 1908. This was the first train to go over the new elevated tracks in March 1906. The Edison Hotel, which replaced Givens Hotel, another city landmark, can be seen to the left. Parts of the Edison, the first two floors, occupy the present building.

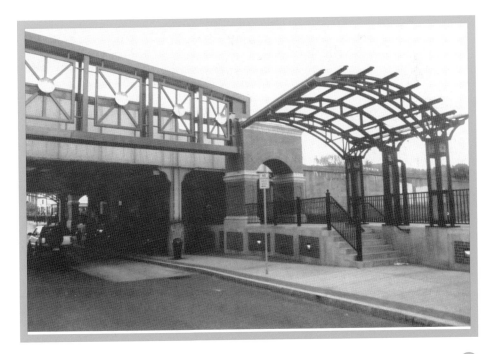

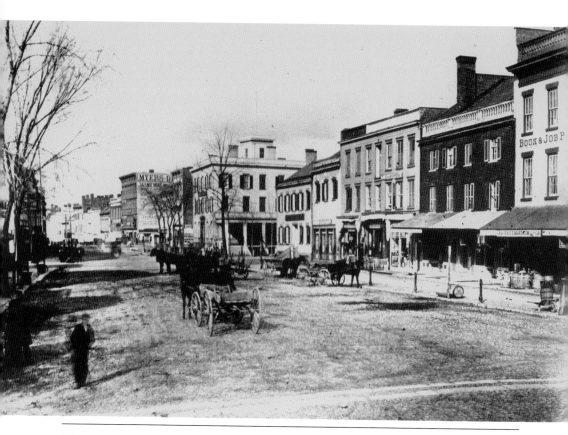

This *c.* 1870 view from Broadway shows State Street to the railroad tracks. Notice the native cobblestone pavements. Givens Hotel (center), which borders a number of tracks, was built by Resolve Givens in 1843. The Myers Block and the State Street Bridge over the Erie Canal can be seen down the street in the distance. The elevated railroad tracks dominate the scene today.

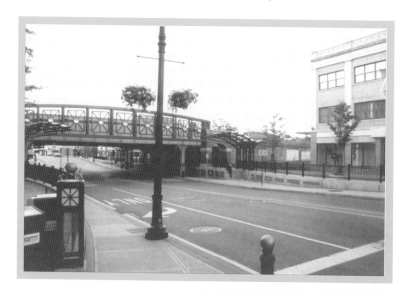

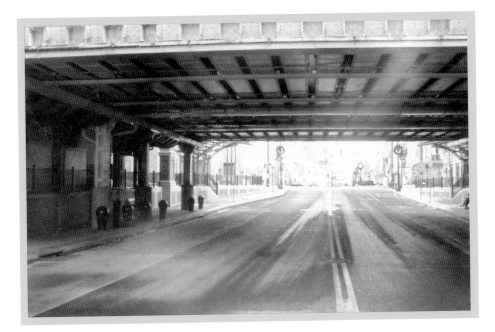

The view looking east toward Crescent Park was totally transformed by the elevation of the railroad, beginning in 1901. Many of the buildings pictured on the left in the 1870s photograph were razed. The Carley House can be seen on the northeast corner of Broadway and State Street. The Western Union telegraph office is before it on the other corner. Notice the horse head hitching post near the three men (center, near the pole). The First Methodist Church steeple is also visible.

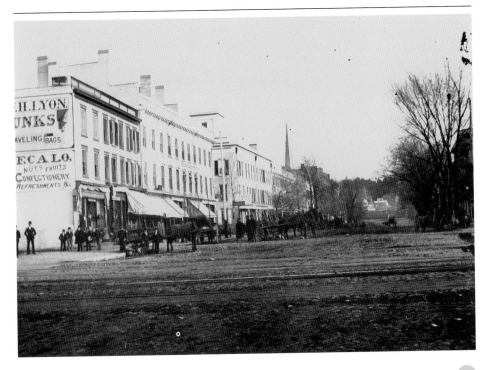

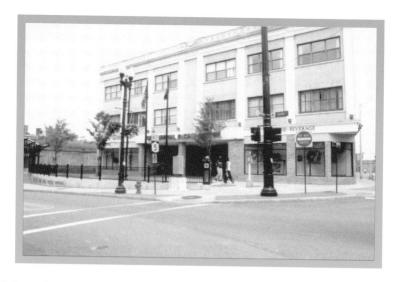

Viewed from the northeast, the block at 203 State Street, between the railroad tracks and Broadway, has changed significantly. In the early photograph are the shop of James W. Mairs (who sold groceries, furnishing goods, and agricultural implements) and the drugstore of W. T. Hanson and Company on the corner.

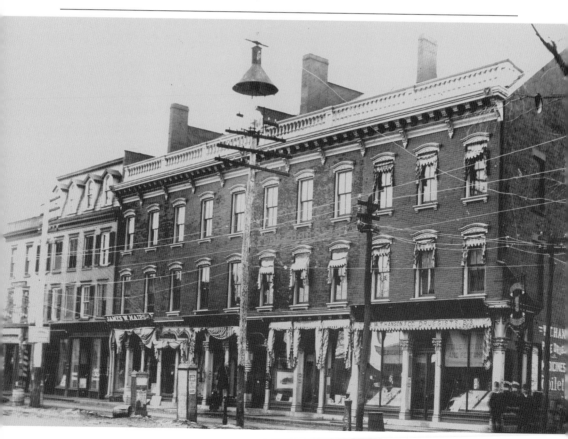

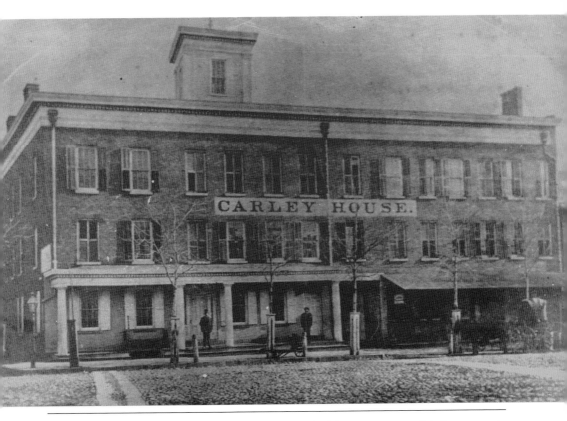

CARLEY HOUSE.

Andrews Devendorf built the Carley House on the northeast corner of Broadway and State Street in 1878 and ran the establishment until 1890. Charles Barhydt took over in 1891 and operated it as the Barhydt House until 1895. In 1895, the building was remodeled, a cupola was attached, and the name became the Vendome Hotel. The Vendome Hotel was a landmark until it was torn down in 1938 to make way for a Woolworth department store.

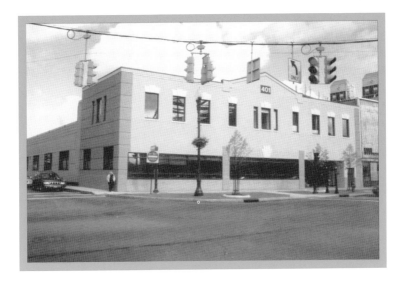

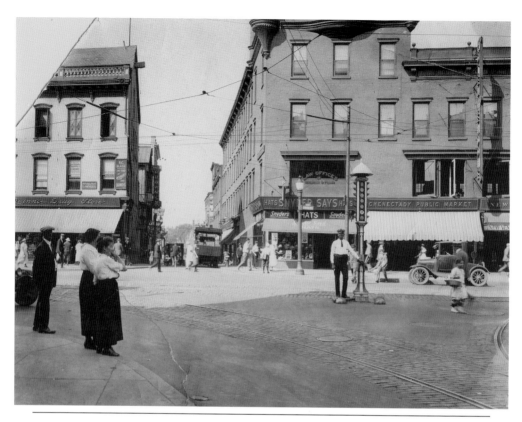

The corner of Broadway and State Street was a busy one in 1924. On the ground floor of the old Vendome Hotel (right), Snyder's was selling hats for 89¢. On the opposite corner, Hanson's Drugstore has become Quinn's. The manually operated traffic light was installed in the early fall of 1924—but seven lights must have been confusing. Today the corner still has a lot of traffic lights.

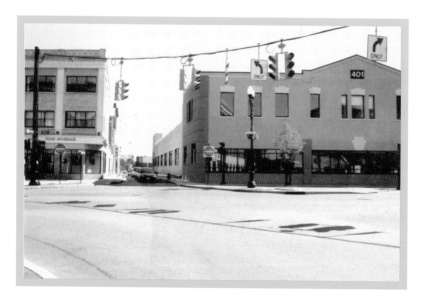

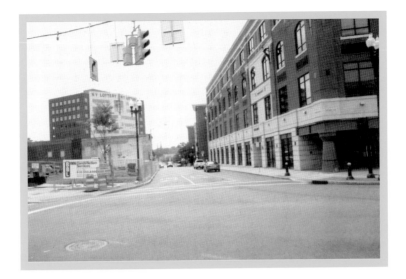

This is the southwest corner of Broadway and State Street. The Mohawk Hotel and Baths was built in 1907. The Schenectady Rotary Club held its first meeting there in 1917. The Mohawk Hotel and Baths was renamed Hotel Schenectady and called Hotel Mohawk, but it was closed in 1962 and was torn down in December 1977. Trolley 551 is going to Rexford Flats. The buggy in front of it is the Electric Express Company, and the saloon behind it is serving Quant's, a Troy-made beer. The Electric Express, which operated at South Church Street and Fuller Street, called for and delivered baggage, at reasonable rates, in Albany, Troy, Ballston, and Schenectady. Today the corner is occupied by the New York State Department of Transportation building.

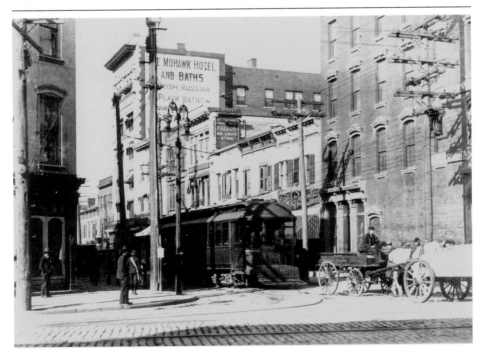

In the *c.* 1900 view, taken looking southeast on State Street to Broadway, the Schenectady Gazette Building stands in the middle of the block. An early Grand Union Tea Company is on the right, and the Union Bank is down on the left. The New York State Department of Transportation building stands here today.

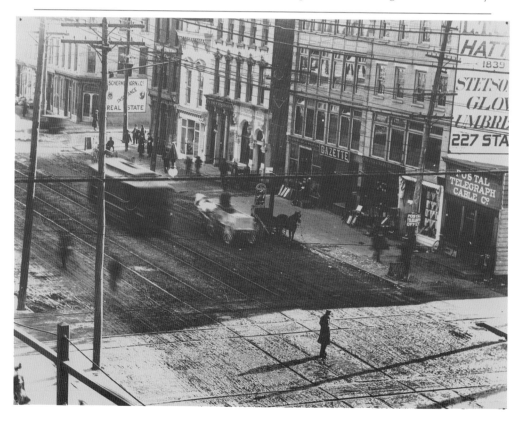

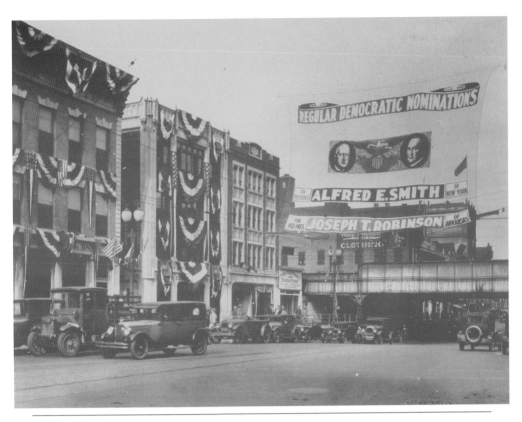

Alfred E. Smith, a New York governor, ran for president in 1928. He lost to Herbert Hoover. Smith was the first Catholic to win a major-party presidential nomination. His running mate, Joseph T. Robinson, was the first Democrat in history to serve as Senate majority leader. This view is looking southwest from State Street toward Erie Boulevard. The Schenectady Gazette Building is in the center.

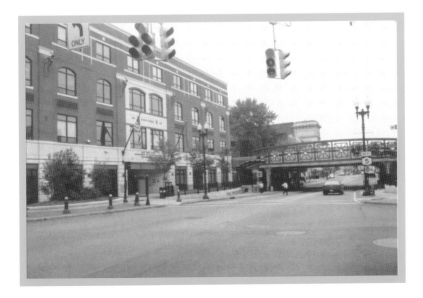

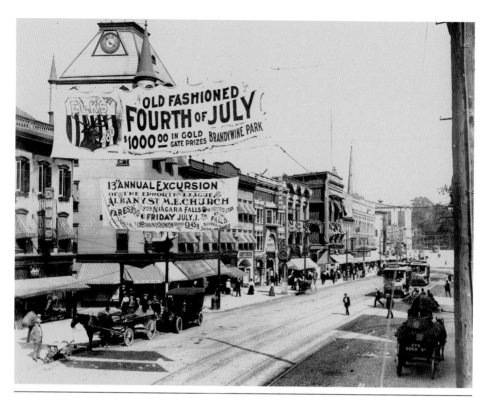

The north side of State Street is shown, looking toward Crescent Park. At 10:20 a.m. one summer morning in 1910, the Elks' banner announces an old-fashioned Fourth of July and the Albany Street Methodist Episcopal Church banner advertises the annual trip to Niagara Falls. The Scotia and Campbell Avenue trolleys head west, and a coal wagon is on the way to make a delivery. The Auditorium theater and the next-door Orpheum Vaudeville House (409–411 State Street) entertained residents. In 1918, the Orpheum Vaudeville House became the Palace Theater, and shortly after that, the New Strand.

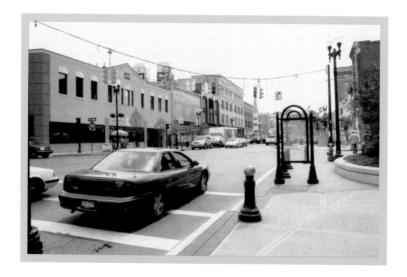

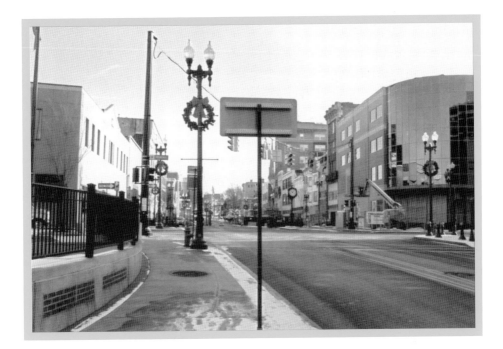

Downtown was a very busy area in the 1900s and right up to the 1960s, when, like in most northeastern cities, people abandoned downtown for the suburbs and shopping malls. Schenectady's downtown is making a major comeback with new hotels, theaters, apartments, and retail shops. Pictured is the south side of State Street from the railroad tracks to Broadway. The Hough Hotel (right, rounded front) stands on the corner of Broadway.

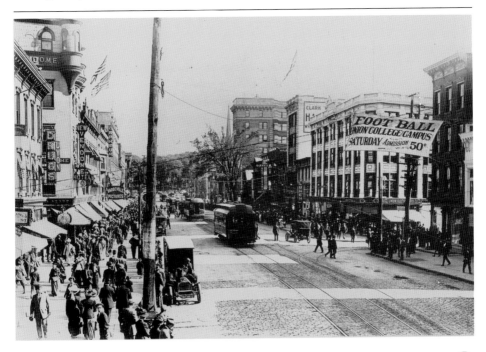

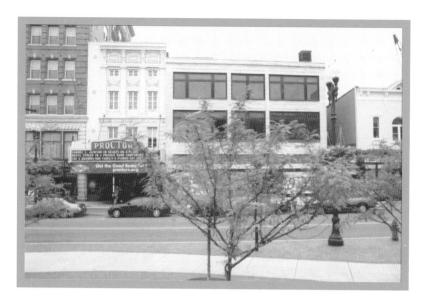

Three of Schenectady's landmarks are pictured in 1925 and today: the Parker office building, now the Parker Inn, built in 1906; the Art Theater that was being converted to Proctor's Theater, which opened in 1926; and the Carl Company, a famed department store. Proctor's Theater is now the largest venue for Broadway plays between Montreal and New York City, the Parker Inn is an upscale hotel, and the Carl Company building is now being renovated and brought back to life.

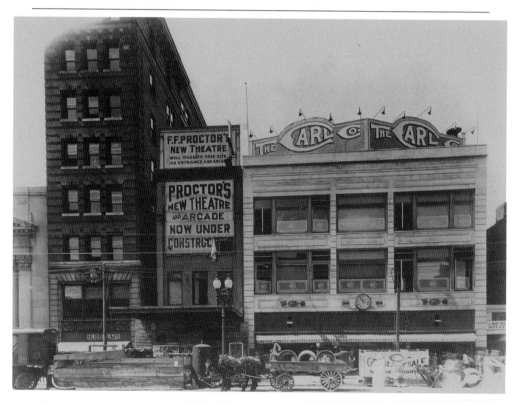

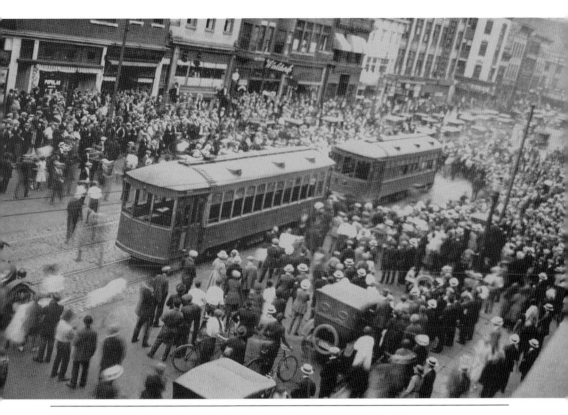

The trolley strike of 1923 saw these two stranded trolleys pelted with stones by the mob. The last trolley ran on December 7, 1941, Pearl Harbor Day. Buses were replacing trolleys. On April 7, 1957, the last trolley in New York State ceased to operate, the Queensburgh Bridge Railway Company in New York City. In July 1960, the Public Service Commission abolished all laws pertaining to the trolley industry. The view is looking southwest down State Street toward Broadway. The Hough Hotel, at the corner of Broadway, is now the site of a new Bow Tie Theater.

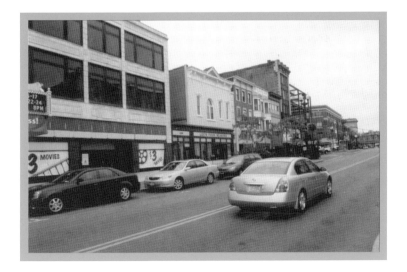

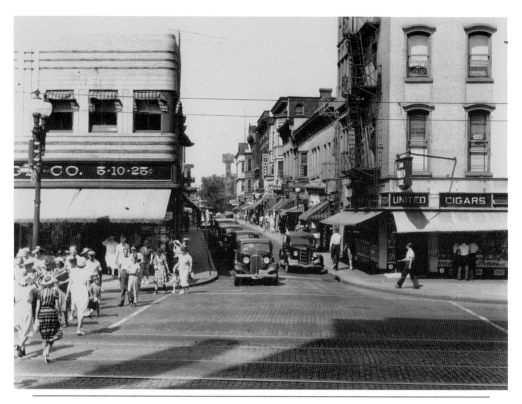

Looking north, the view is of State Street at Jay Street. During the early 1930s, five-and-dime stores and many small shops satisfied shoppers. At the end of Jay Street, at Franklin Street, was the burlesque theater the Van Curler Opera House, built in 1898. Today Jay Street is a pedestrian mall.

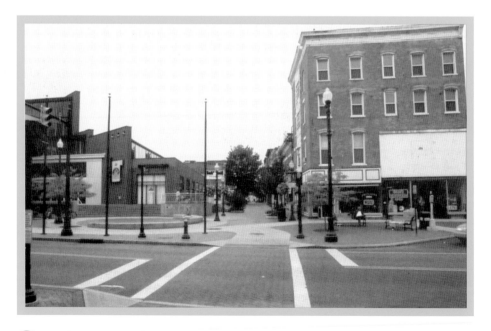

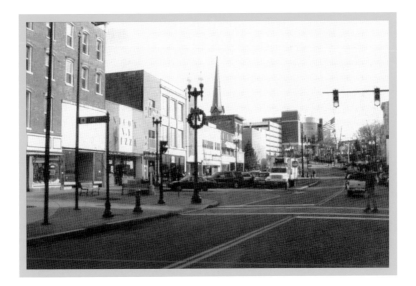

The streetscape has changed considerably over the years, as many buildings have been torn down. Here is the north side of State Street, from Jay Street to Crescent Park. Notice how wooded Crescent Park was in the late 1800s. The Wallace and Company store is now the Center City sporting complex. The Lorraine Block (last large building)—named for the daughter of its builder, Welton Stanford, son of state legislator Charles Stanford and brother of railroad giant Leland Stanford—was demolished in 1972 for the Albany Savings Bank.

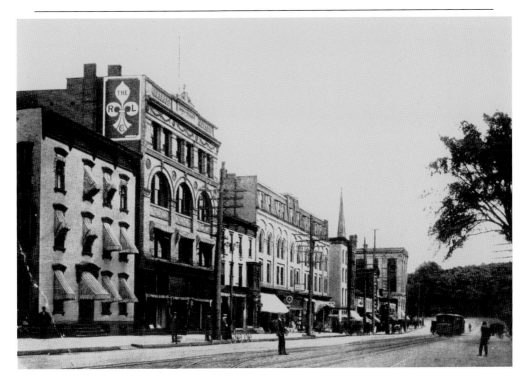

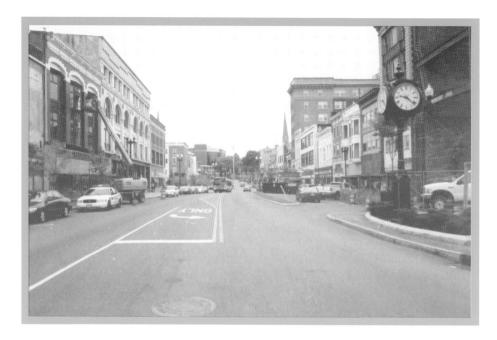

A parade at the end of World War I, in 1918, brought thousands downtown. The view is looking east from Broadway toward Crescent Park.

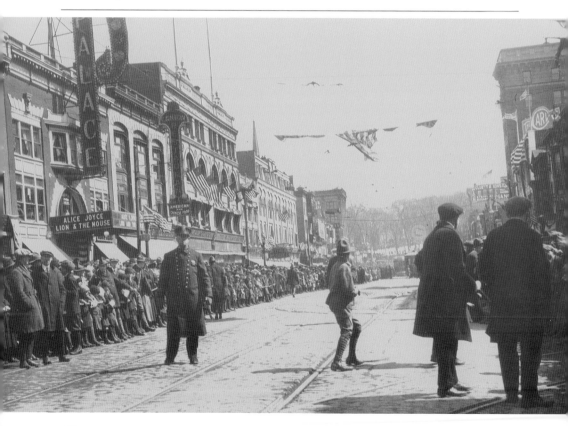

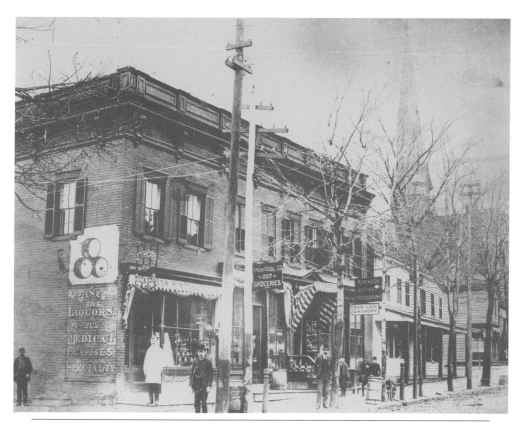

This is the view between Clinton and Barrett Streets prior to 1902 when the first two buildings were demolished for the Lorraine Block. The Park House, later Wasson's Park House and Saloon, on the right, remained, but it too was torn down shortly after the Lorraine Block was built for the Schenectady Illuminating Company. The entire Lorraine Block was razed in 1972 and now is the home of the Citizens Bank.

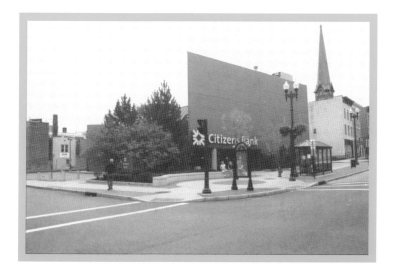

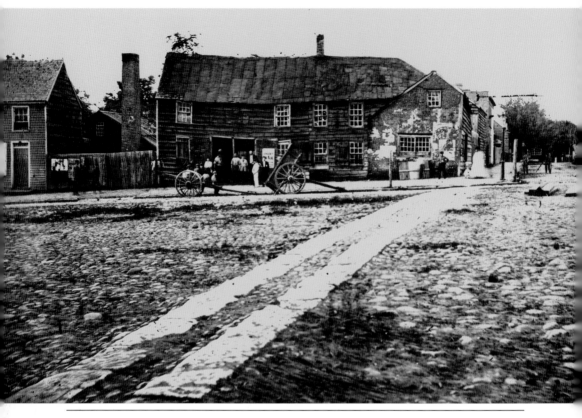

The Clute and Reagles Agricultural Implements and Wheelbarrow Manufactory was located on the northwest corner of State Street and Lafayette Street in the 1840s. The company made wagons and ploughs. Here State Street is at its widest, where it met the Albany Schenectady Turnpike (now part of State Street) and the King's Highway (now Albany Street).

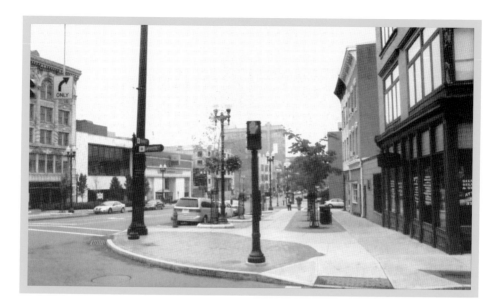

The view of upper State Street at Lafayette Street is looking west toward downtown. A mix of retail, commercial, and apartment buildings has been replaced by a few law offices in surviving buildings.

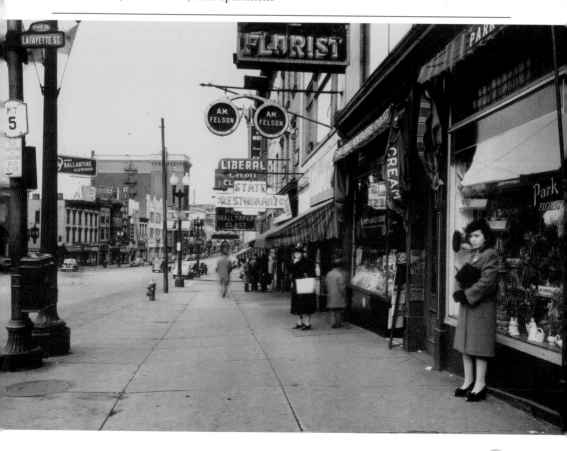

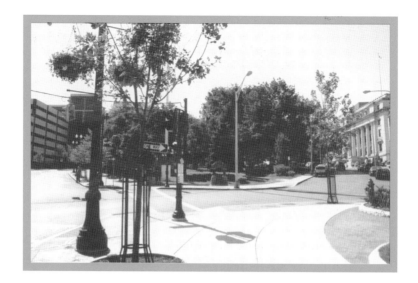

This is Crescent Park, located between Nott Terrace and Veeder Avenue and Lafayette Street. The early view dates from the 1870s. Weekly bank concerts were heard here after a larger bandstand was built under the socialist mayor George Lunn in 1912. The bandstand was removed in 1948. The park now features many monuments.

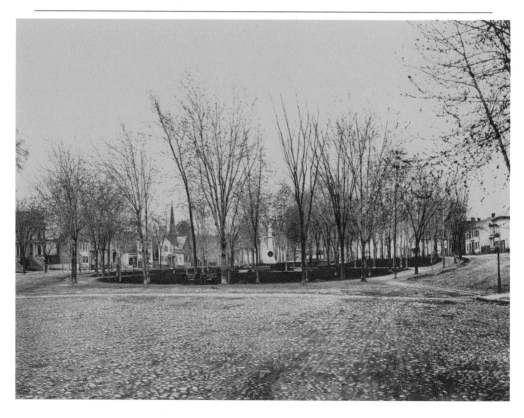

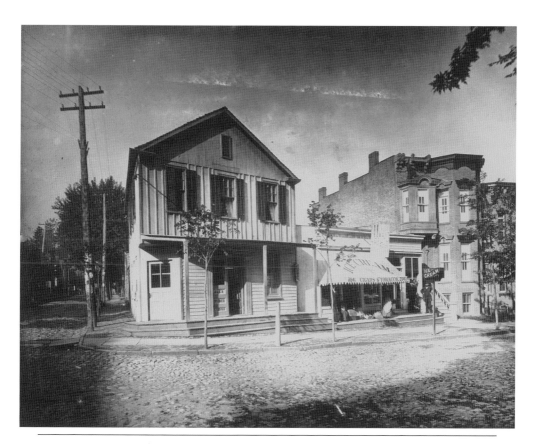

The southwest corner of Veeder Avenue and State Street (Albany Street), once the location of ice cream, beer, and apartments, has been transformed into the county's government block today, with the county office building and courthouse. Notice that both Veeder Avenue and State Street are still cobblestone streets in the late-19th-century photograph.

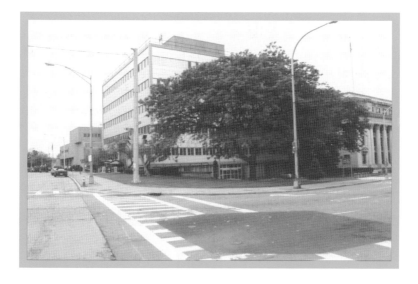

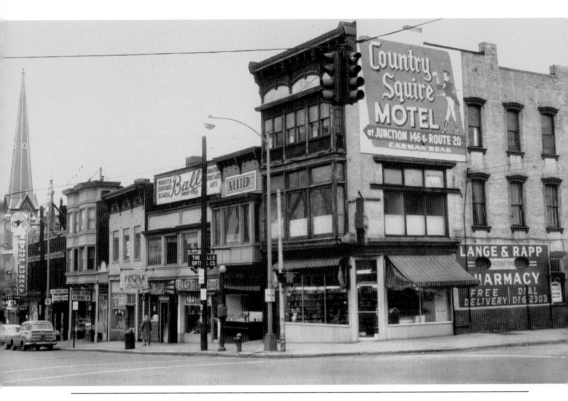

The northwest corner of Nott Terrace and State Street was an eclectic mixture of commercial, retail, and residential units until the 1970s. In recent years, the block became the home of MVP, one of the largest health insurance providers.

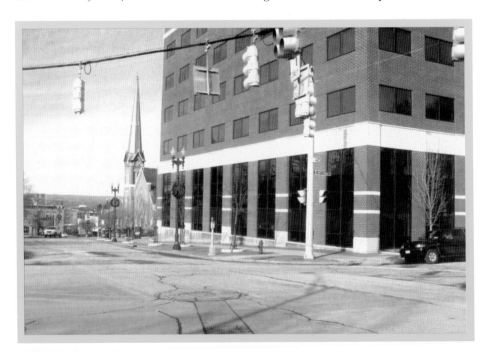

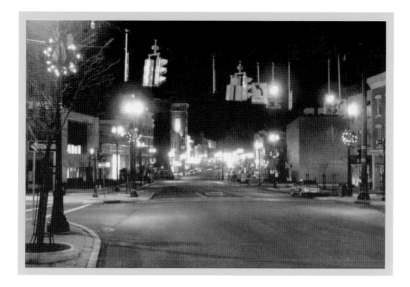

Christmas evening in downtown in 1948 is matched with Christmas 2006. Much has transpired in 58 years. Schenectady has had its share of downfalls, but the future is bright for the city as an urban renaissance is now taking place. The view is from Crescent Park, looking west.

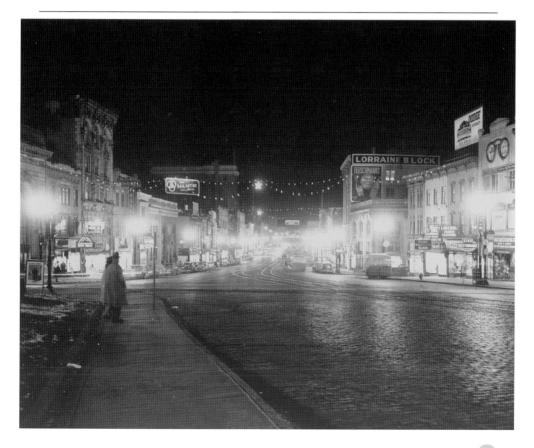

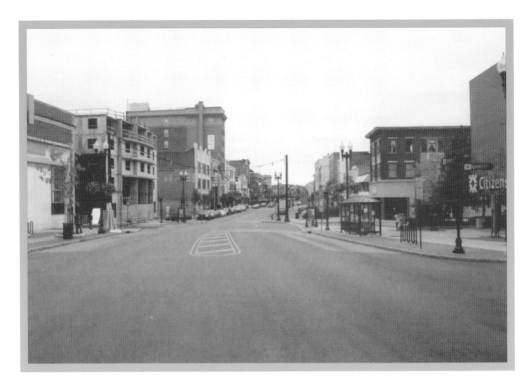

Although the streetscape has changed considerably since the Roaring Twenties, the downtown is undergoing revitalization efforts, and most of the buildings today are occupied or being renovated into apartments and commercial and entertainment spaces. Proctor's Theater is now the largest venue for Broadway-size theater between Montreal and New York City.

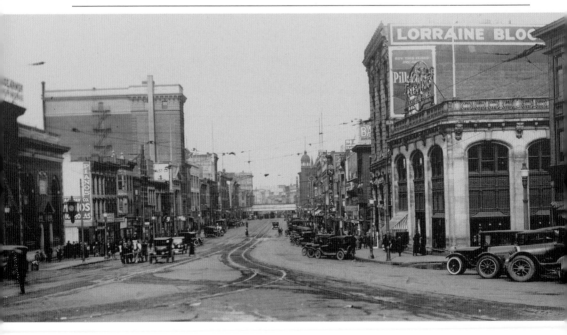

ERIE CANAL, LOOKING NORTH

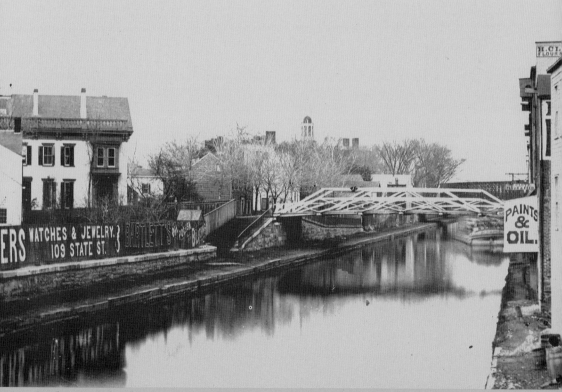

Looking north, this view is of the Erie Canal from the State Street Bridge to the Liberty Street Bridge. The Erie Canal came through Schenectady in 1825, transforming the city from a broom and boat maker into a canal town. Many of the industries that originally were located farther west on the Mohawk River set up shop along the canal. The canal was used until around 1915, when the Barge Canal utilized more of the river system and made the inner canal less desirable. The city began filling it in, and by 1925, the Erie Canal became Erie Boulevard, the widest and best-lit boulevard in the nation at the time.

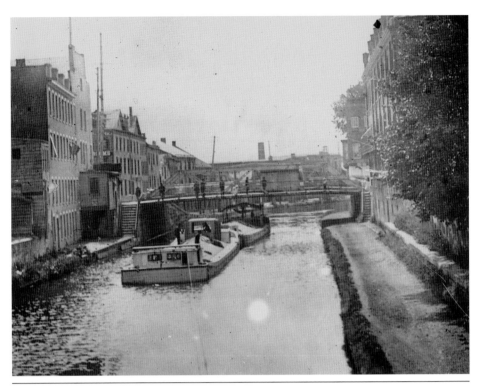

The early view, looking south, shows the Erie Canal from the Liberty Street Bridge to the State Street Bridge. The towpath (right) was only eight feet wide and was known as the Wedge. The present-day view shows Erie Boulevard, with all the buildings on the left gone and the Wedgeway Building on the right remaining.

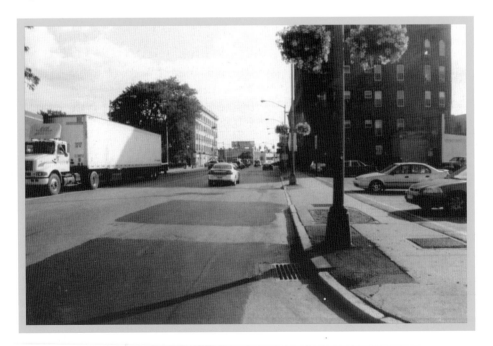

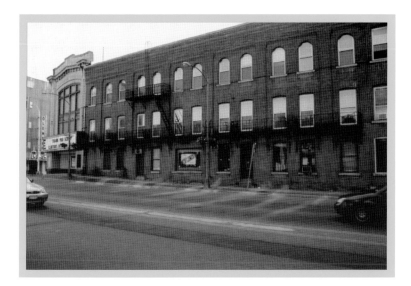

An early theater, the Wedgeway, entertained Schenectadians for years. F. F. Proctors took it over and ran it until the Art Theater on State Street was remodeled into the present Proctor's. This theater then was known as the State Theater. Notice the horse and buggy on the towpath next to the building. The towpath was then called the Wedge. A whole story's worth of fill was used to get the road to the current level. The Wedgeway Building still remains.

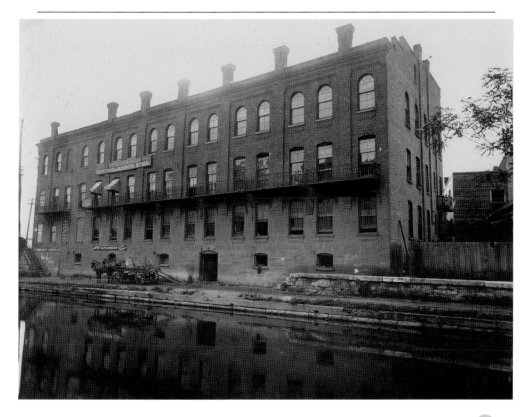

By 1915, the Erie Canal was no longer in use and started to become everyone's garbage dump. The Liberty Street Bridge can be seen in the middle. By 1925, the canal was filled in completely. The buildings that lined the canal were useful during the canal days, but by the urban renewal days of the 1960s and 1970s, they were torn down. The last to go was the Ellis Building (far right), in 1975. Only the Wedgeway Building (left) remains.

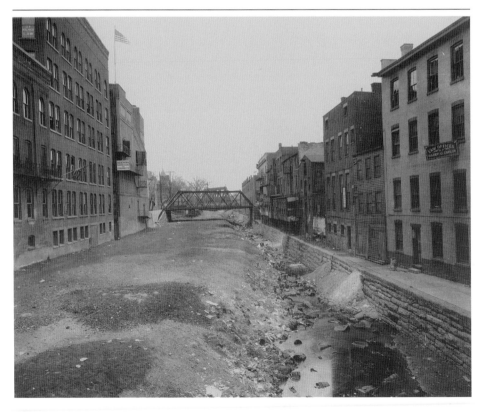

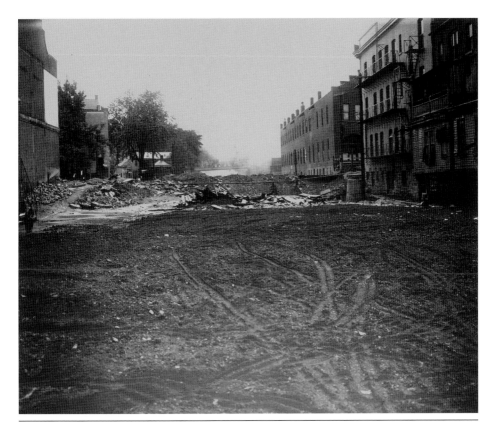

The Liberty Street Bridge was taken down, and the canal was filled in. The buildings on the right in the c. 1925 photograph are the Crown Hotel, at 102–104 Wall Street (south of Liberty Street), and the Arcade Building, which replaced Clute Brothers Foundry on the north side of Liberty Street in 1890. The CIO Union Hall was located here. The Arcade Building was torn down in 1955 and the Crown Hotel in 1971.

ERIE CANAL, LOOKING NORTH

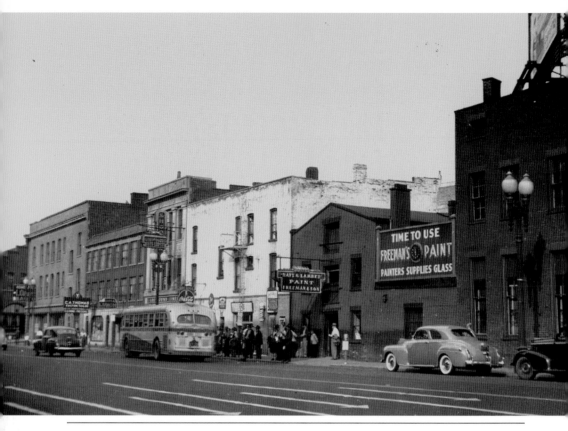

Erie Boulevard is pictured, looking northeast from the southwest corner of State Street. In the early photograph, from the days before urban renewal, the Crown Hotel is on the far left, and the Ellis Building is on the right. Wall Street is located behind them.

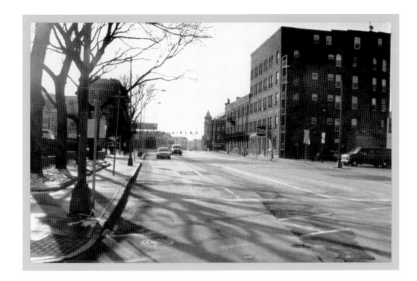

Here Erie Boulevard is pictured, looking south from the Wall Street entrance. In the early view, the Wedgeway Building stands with the State and Erie Theaters next to it. The Erie Theater was razed in 1963 and the State Theater in 1985. The Crown Hotel is on the left with a man standing on a ladder performing work. The Nicholas Block can be seen in the background.

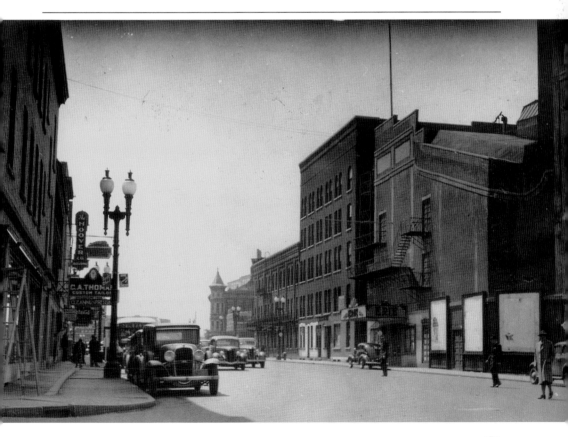

Erie Canal, Looking North

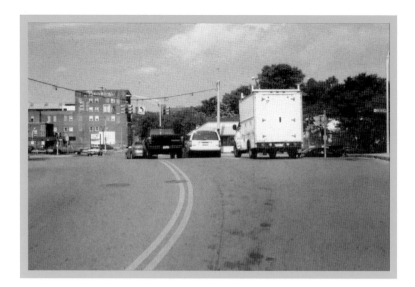

Shown are the Liberty Street Bridge and the Wall Street entrance (left). The building to the right is Clute Brothers Foundry, and the residence on the other side of the canal is the John Ellis Mansion. Ellis was the founder of the Schenectady Locomotive Works. His son Charles, who also lived there, was a benefactor to Ellis Hospital, named for him. Electrical genius Charles Steinmetz lived in this house until 1903.

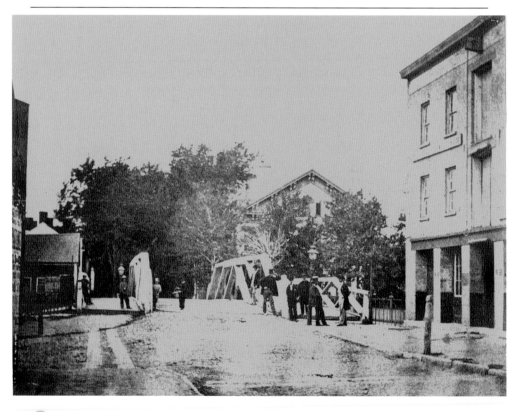

ERIE CANAL, LOOKING NORTH

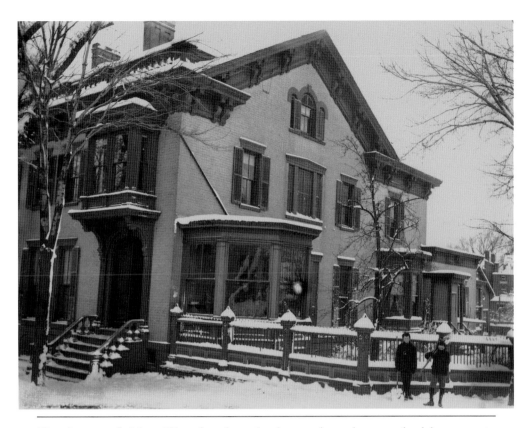

The house of John Ellis, founder of Schenectady Locomotive Works, stood at 231 Liberty Street. General Electric's Steinmetz rented this house, which soon became known as Liberty Hall. The carriage house in the back served as the first industrial research laboratory in the county until it burned to the ground on January 20, 1901. The house was demolished in the 1950s. A Burger King is on the site today.

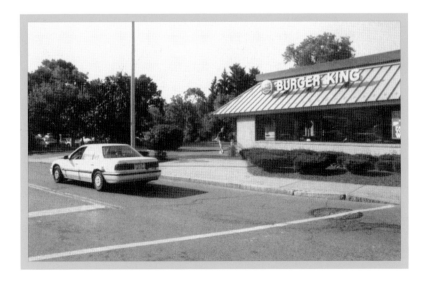

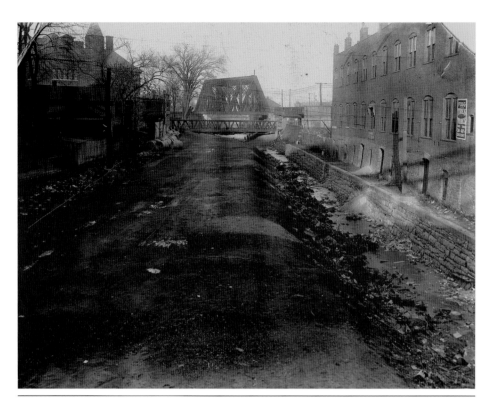

Shown is the stretch from Liberty Street to the Union Street Bridge. In the *c.* 1920 image, sewer pipes can be seen that will be used in the middle of the filled-in canal. The building to the right of the canal is the Clute Brothers Foundry (later the Arcade Building), which became famous for building the rotating gears and donkey engine for the USS *Monitor* during the Civil War. The railroad bridge still stands today and most of Elbow Street, called South College Street today, is devoid of any houses.

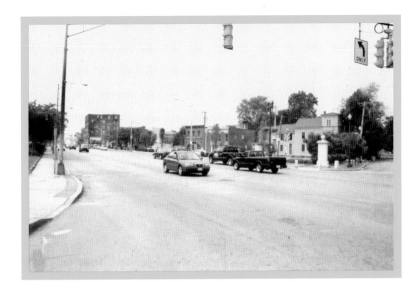

This view looks south toward State Street. The 1880s photograph was taken from the Union Street Bridge. The houses on the towpath side of the canal lay between Elbow Street (now South College Street) and the canal. Elbow Street veered to the right at the Liberty Street Bridge, as seen here. Notice the canal barge past the bridge and heading for the basin, the widest part of the canal on the south side of State Street.

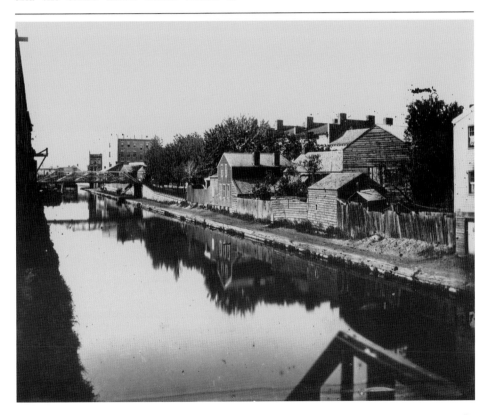

ERIE CANAL, LOOKING NORTH

The c. 1920 view was taken looking south toward the Liberty Street Bridge from the Union Street Bridge. The Erie Canal is being filled, the Clute Brothers Foundry is on the left, and South College Street is on the right.

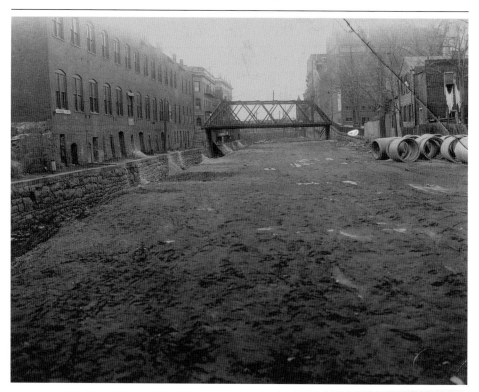

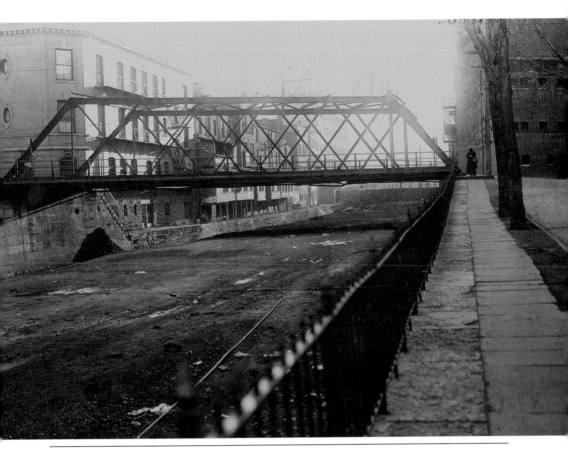

This *c.* 1920 close-up shows the Liberty Street Bridge. The Crown Hotel is on the left, and the State Street Bridge is beyond the Liberty Street Bridge. Here engineer Charles Steinmetz's escaped pet alligators were rescued one night. Steinmetz often photographed this bridge, which was just outside his Liberty Street home.

ERIE CANAL, LOOKING NORTH

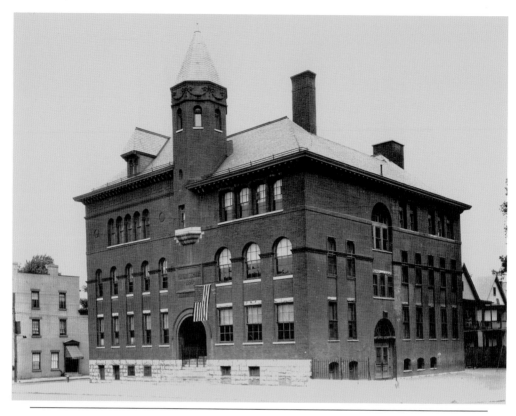

The Union Street School was built in 1890 to replace an earlier public school that opened in 1857 in the (1804) West College building, forerunner of Union College and later city hall (1814–1857). Pictured around 1915, this building was part of the public school system until around 1940. It was remodeled into veterans' apartments after World War II, and it was demolished in 1960. Since then, the site has been a parking lot for the Van Dyke jazz club and restaurant.

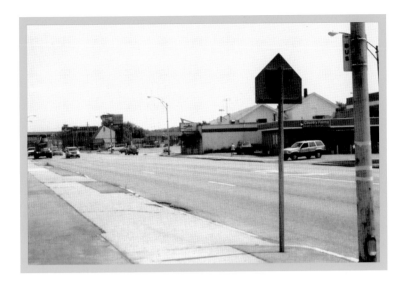

Maxon and Company Grain Elevator stood 10 stories high, just north of the Jefferson Street Bridge over the Erie Canal. George G. Maxon and partner John Thompson built the elevator in 1865. The Delaware and Hudson Coal Company purchased it after 1886 and tore it down, replacing it with freight buildings, one of which still exists. The photograph of the grain elevator building was taken from the Green Street Bridge in the 1870s. The buildings to the right include Van Slyck's coal storage shed, wholesale broomcorn storage sheds, and a broom factory.

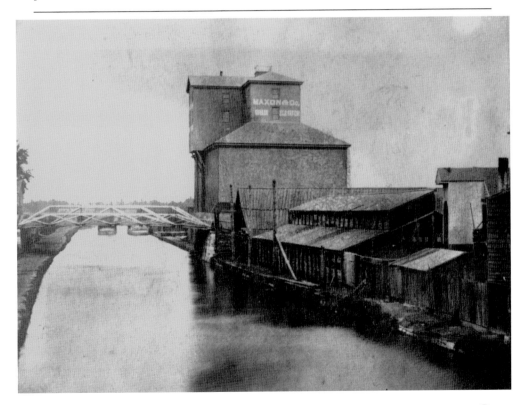

ERIE CANAL, LOOKING NORTH

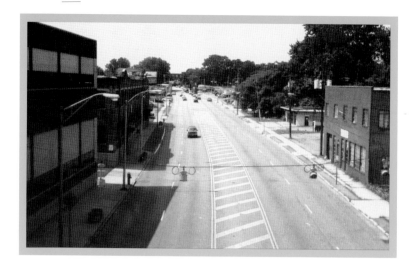

The view looks south toward State Street. The c. 1885 photograph was taken from the top of the Maxon and Company Grain Elevator building. The Jefferson Street Bridge, the railroad bridge, and the State Street Bridge can all be seen. The Delaware and Hudson Coal Company's freight buildings are in the foreground, and Van Vorst lumberyard is to the right. The Union College building, with the steeple, is in the right distance. In the present-day image, the Siemens office building stands on the right side of Erie Boulevard.

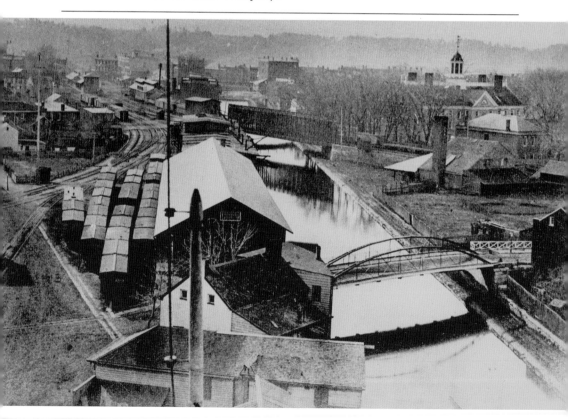

Erie Canal, Looking North

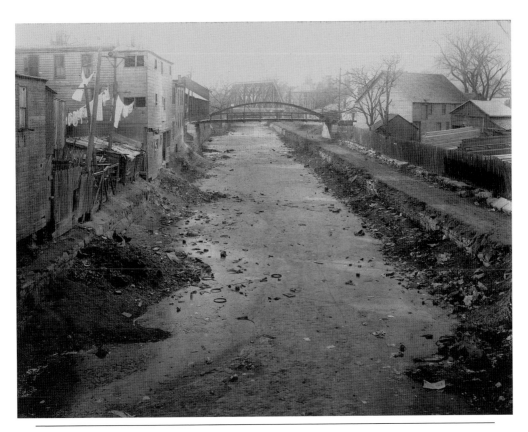

The c. 1910 view, looking south, shows the Erie Canal is being filled in from Monroe Street to the Jefferson Street Bridge. This was mostly a residential section at the time. To the right is the city's Stockade section, now one of the most historic districts of the city.

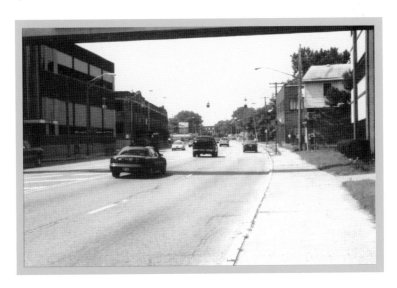

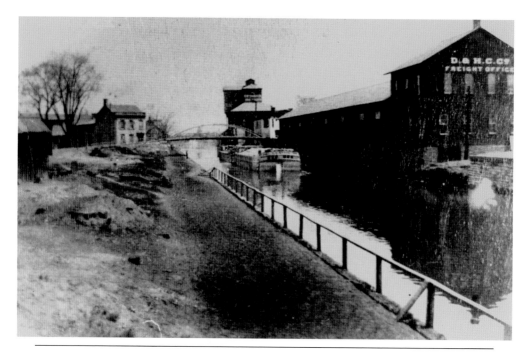

The *c.* 1889 view was taken from the towpath at Green Street looking north toward the Jefferson Street Bridge. The Delaware and Hudson Coal Company's freight building is on the right. The Maxon and Company Grain Elevator building is in the middle distance.

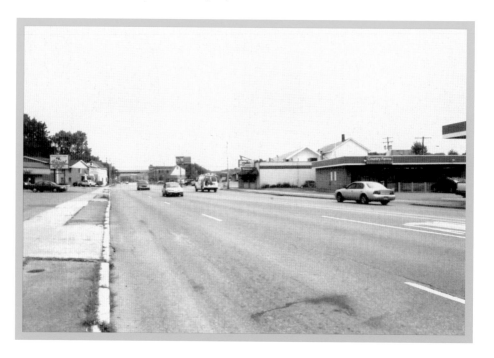

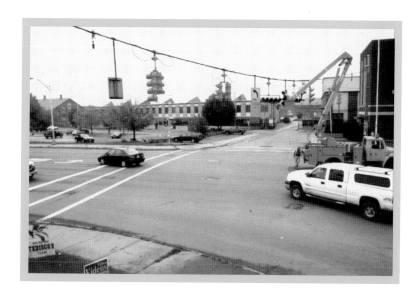

Workers from the American Locomotive Company (Alco) plant and others could cross the canal either in a vehicle on either the Nott Street Swing Bridge, which swung to the left, or on foot using the overpass footbridge. The c. 1915 photograph shows pedestrians and horse-drawn vehicles using the swing bridge.

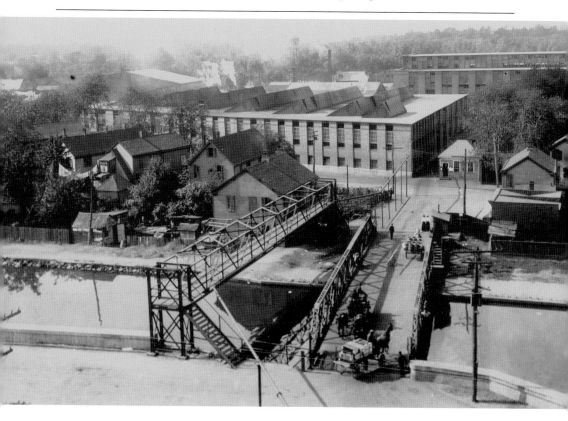

The 1872 view shows the Erie Canal past Nott Street heading toward Freeman's Bridge (background). Notice the farms and homes. This site, known as the Poor Pasture, was donated by Hans Janse Enkluys in 1864 for the downtrodden. It was taken over by American Locomotive Company around 1901. Another bridge near Mohawk Avenue was replaced with a swing bridge and footbridge by 1915.

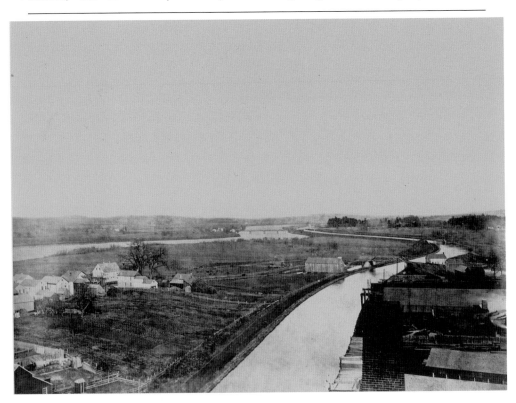

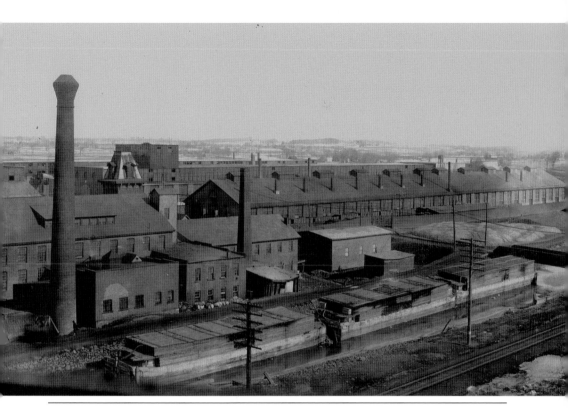

American Locomotive Company was the second-largest steam locomotive builder in the United States, producing over 75,000 locomotives. It produced the first commercially successful diesel-electric locomotive in 1924 in a consortium with General Electric and Ingersoll-Rand. Unable to withstand competition from General Electric and others, it closed its Schenectady locomotive plant in 1969. Its long history includes making cars, trucks, and tanks during World War II and the Korean War.

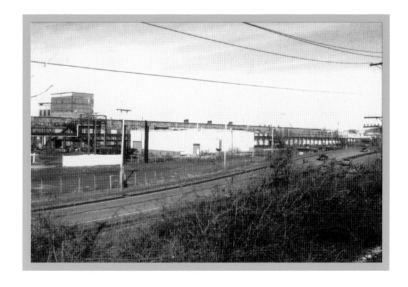

ERIE CANAL, LOOKING NORTH

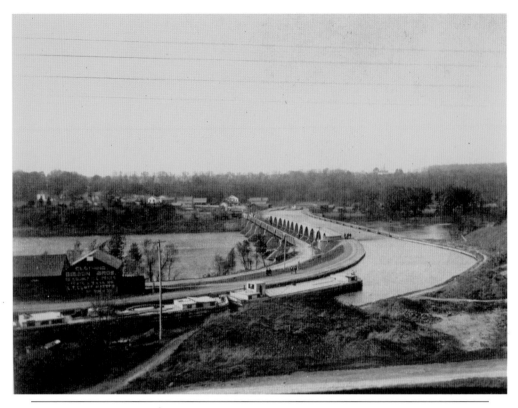

The Erie Canal entered the city via the Rexford Aqueduct, which curved across the Mohawk River. Built in 1842, this aqueduct replaced the original 1828 Rexford Aqueduct. It was built of random ashlar masonry and limestone and consisted of 13 masonry arches spanning about 45 feet to support the towpath and 14 masonry piers approximately 45 feet wide to support the original timber canal trunk. It was removed in 1918, and the blocks lay not far from the original location.

CHAPTER

ERIE CANAL, LOOKING SOUTH

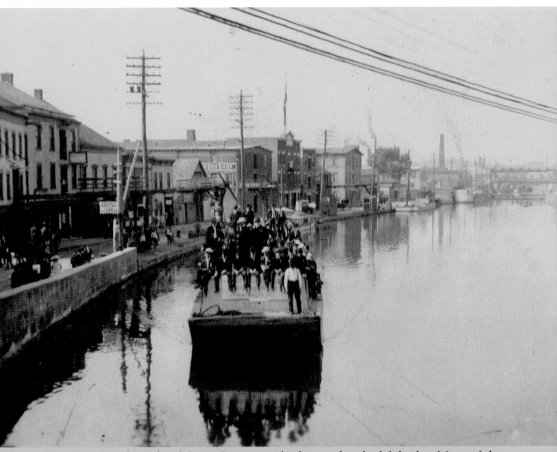

The Erie Canal south of State Street is pictured, with Dock Street and the east side of the Erie Canal basin. Just south of the State Street Bridge was the widest part of the canal, at 100 feet across. The towpath is on the right, and in the background is the lift bridge. Many of the establishments on Dock Street were coal companies that received the coal by barge and, later, by train in the back. The folks on the barge are celebrating some event at 406 State Street.

The widest part of the canal was called the basin. In this 100-foot-wide area from Dock Street north to the State Street Bridge, boats could turn around. Many coal firms had their offices and stores here. Brown's Furniture Ware Rooms (foreground) and the Ellis Building can be seen on the right on both sides of the bridge.

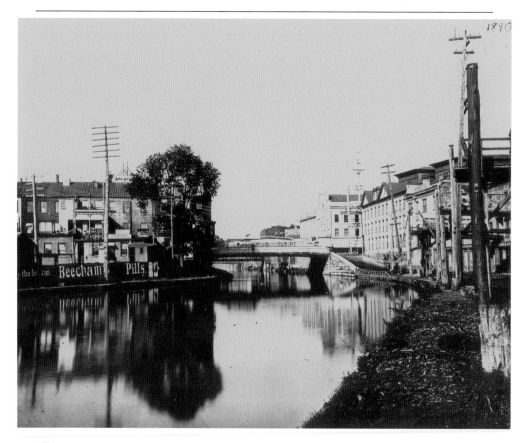

ERIE CANAL, LOOKING SOUTH

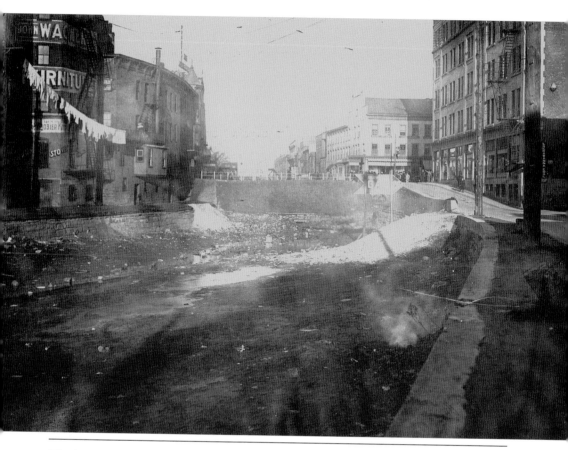

The basin was filled in around 1915. The Ellis Building (second from the right, now gone) was built around 1822, shortly before the canal was dug. Robert Ellis was a tailor. The Masonic temple (right) still stands. When Erie Boulevard was opened to traffic in 1925, it was promoted as the best-lit boulevard in the country.

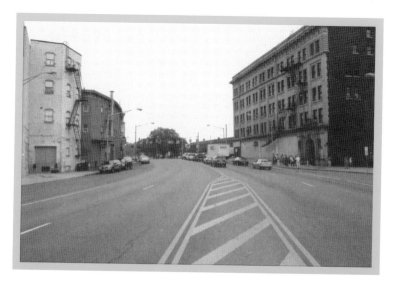

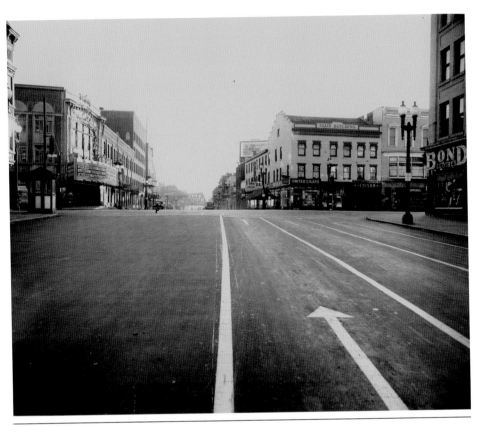

In 1939, the State Theater on Erie Boulevard is showing *On Borrowed Time*, with Lionel Barrymore, and *Blondie Takes a Vacation*, with Penny Singleton (Blondie Bumstead) and Arthur Lake (Dagwood).

The *c.* 1822 Ellis Building (light-colored, now gone) was United Cigars at the time. It was torn down in March 1975, and its demolition became one of the city's first preservation battles.

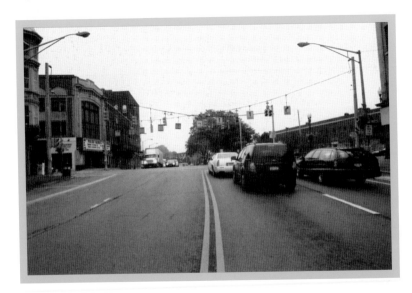

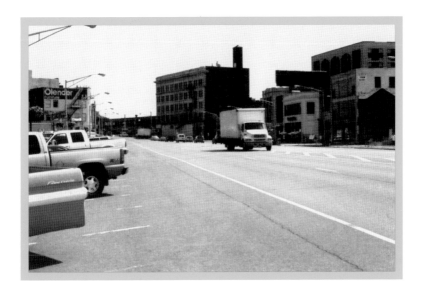

Skating on the Erie Canal was a popular winter pastime. The c. 1899 photograph was taken by electrical engineer Charles Steinmetz. The location is the basin, south of State Street. The turret of the Edison Hotel can be seen in the background.

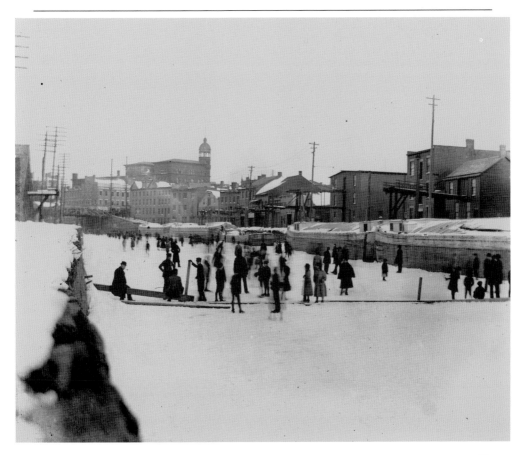

Erie Canal, Looking South

A lift bridge was used by the Mohawk and Hudson Railroad to connect to the Saratoga and Schenectady Railroad, making it the first railroad junction in America. It began near State Street in 1832. The early view, looking south, shows the lift bridge opposite Railroad Street, the Washington Avenue Bridge in the background, the towpath on the right, and Dock Street on the left.

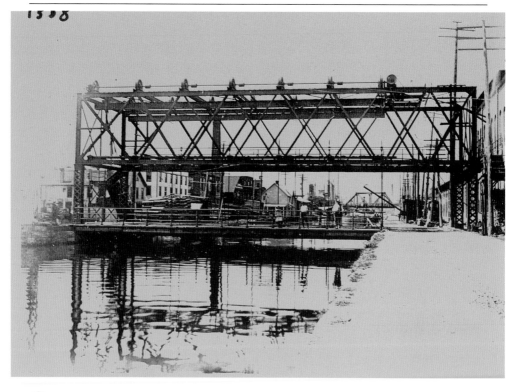

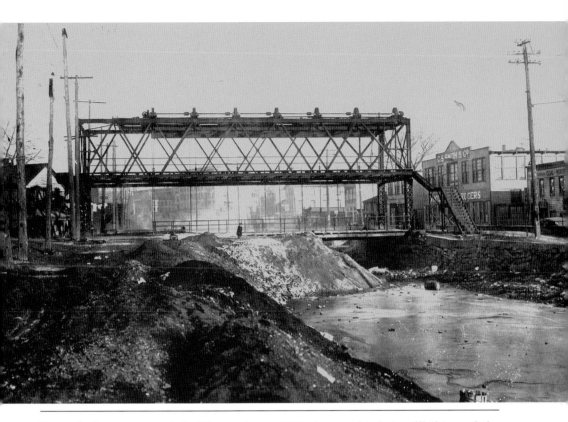

Few of the commercial buildings that stood on Dock Street in the canal days remain today. Here, looking north around 1920, the canal is being filled in and the lift bridge will soon be removed.

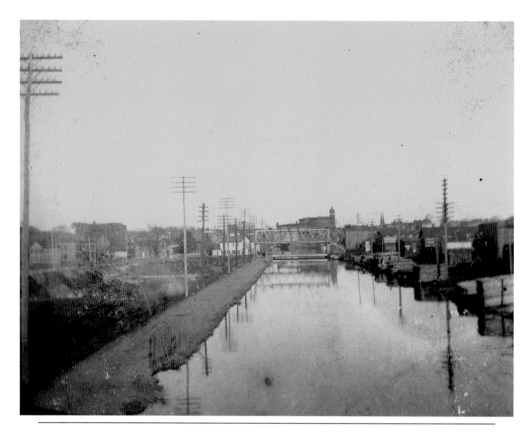

The long view of the canal was taken looking north from the Washington Avenue Bridge around 1900. The towpath is on the left, and Dock Street is on the right. The Edison Hotel is visible in the background. Today Erie Boulevard is being redesigned once more into a more modern roadway with new development proposed on both sides.

ERIE CANAL, LOOKING SOUTH

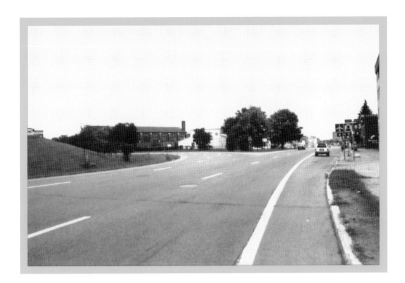

The vintage photograph, taken around 1890, shows the Washington Avenue (Rotterdam Street) Bridge. It was taken looking north from the Westinghouse Agriculture Machinery Works.

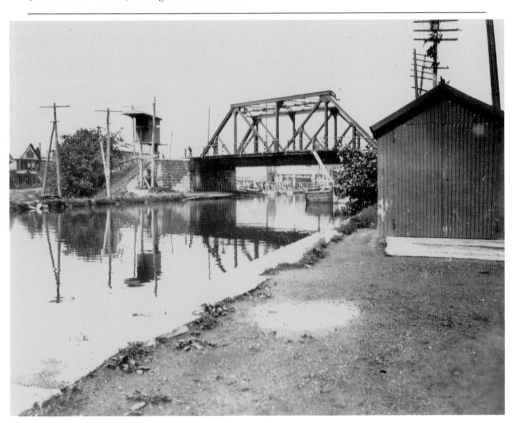

Erie Canal was filled in, and the Washington Avenue Bridge was removed. The early view shows the lift bridge is in the process of being removed. Two early Edison Electric (which would become General Electric) buildings (right) are still being used today by private business and county government.

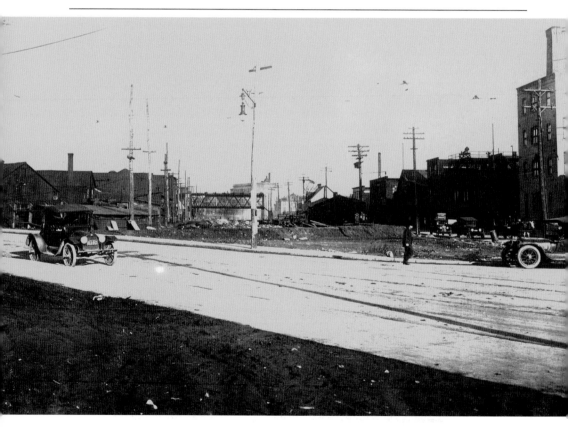

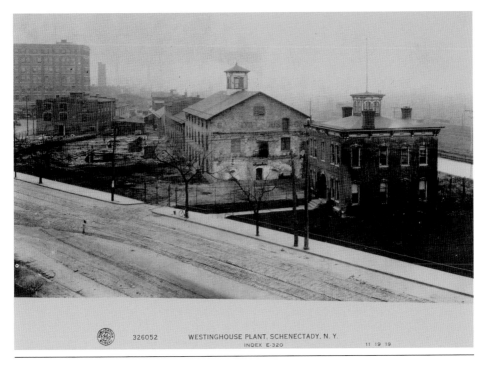

Westinghouse threshers were well built and popular. In 1865, George Westinghouse Sr. moved his agricultural machinery business from Central Bridge to the junction of old Rice (River) Road and Edison (Kruesi) Avenue, alongside the Erie Canal. Here George Westinghouse Jr. invented the air brake for trains, after conceiving the idea while riding the Mohawk and Hudson Railroad between Albany and Schenectady. After learning the trade, he moved to Pennsylvania to form the Westinghouse Electric Company. General Electric tore down the old Westinghouse buildings in 1932 to erect a new studio for WGY, one of the oldest radio stations in the country.

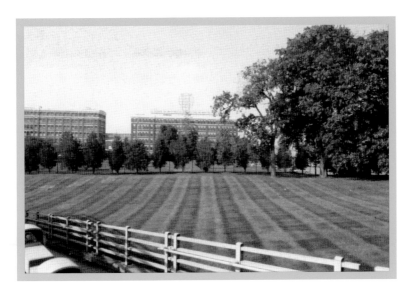

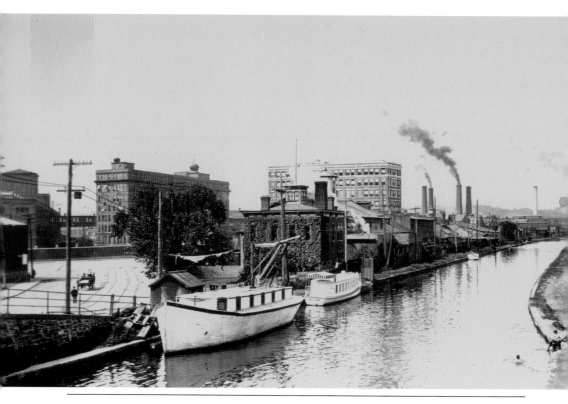

Looking south, the 1914 view shows the canal from the Washington Avenue Bridge. The former Westinghouse foundry buildings are near the canal boats to the right of Edison Avenue. Farther back are the General Electric buildings along the east side of the canal. In the present-day photograph, Building 2 is on the left. The larger building, topped by the General Electric logo (locally known as "the meatball"), was constructed in 1923 as the canal was being filled. The east wall of the canal is now used to delineate the parking lot.

ERIE CANAL, LOOKING SOUTH

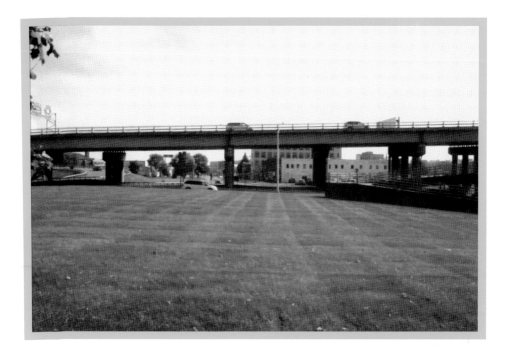

A boy and girl walking their dog along the Erie Canal around 1890 are seen here. The early image, taken looking north toward the city, shows Westinghouse Agricultural Works (center), the Washington Avenue (Rotterdam Street) Bridge (left background), and the Edison Electric (General Electric) works (right). From here, the canal continued into Rotterdam Junction and through to the west.

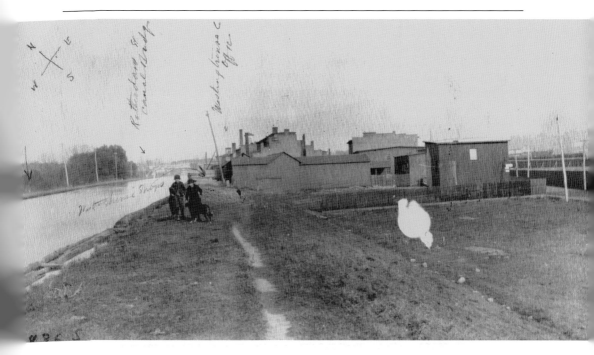

ACROSS AMERICA, PEOPLE ARE DISCOVERING SOMETHING WONDERFUL. *THEIR HERITAGE.*

Arcadia Publishing is the leading local history publisher in the United States. With more than 3,000 titles in print and hundreds of new titles released every year, Arcadia has extensive specialized experience chronicling the history of communities and celebrating America's hidden stories, bringing to life the people, places, and events from the past. To discover the history of other communities across the nation, please visit:

www.arcadiapublishing.com

Customized search tools allow you to find regional history books about the town where you grew up, the cities where your friends and family live, the town where your parents met, or even that retirement spot you've been dreaming about.